IMAGES
of America

FENWAY PARK

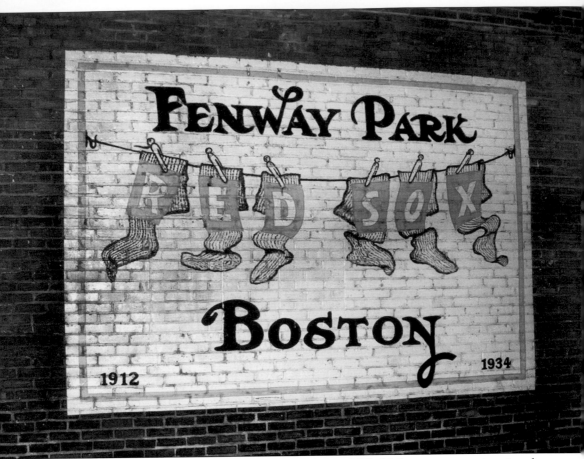

Sporting the years 1912 and 1934, this replica of the 1912 World Series program is painted on the brick wall behind the third-base grandstand at Fenway Park. The two years on the mural indicate the year Fenway Park was originally constructed and the year it was refurbished. The initial construction was done under the ownership of John I. Taylor, and the rebuilding took place after Tom Yawkey purchased the team in 1933. (Courtesy of the Boston Public Library.)

ON THE COVER: A lone figure stands on the third-base roof of Fenway Park taking in the 1914 World Series between the Boston Braves and Philadelphia Athletics. On the first-base roof a handful of men do the same. Shown in the distance is the area known simply as the Fens, from which the park derived its name. The building in the distance on the far right is the "brand new" Museum of Fine Arts, constructed in 1909. (Courtesy of the Boston Public Library.)

IMAGES
of America

FENWAY PARK

David Hickey, Raymond Sinibaldi,
and Kerry Keene
Foreword by Jim Lonborg

ARCADIA
PUBLISHING

Published by Arcadia Publishing
Charleston, South Carolina

Printed in the United States of America

Library of Congress Control Number: 2011936768

For all general information, please contact Arcadia Publishing:
Telephone 843-853-2070
Fax 843-853-0044
E-mail sales@arcadiapublishing.com
For customer service and orders:
Toll-Free 1-888-313-2665

Visit us on the Internet at www.arcadiapublishing.com

For Corey and our three wonderful children
Shawn, Sam, and McKenna.

—David Hickey

"And if they turn out good enough, I owe every
word to you." For Dad, Fenway, and 1967.

—Raymond Sinibaldi

To Pam, I am forever grateful for your endless patience and support.

—Kerry Keene

CONTENTS

FOREWORD

I was a 23-year-old pitcher for the Red Sox when I saw Fenway Park for the first time. It looked like just an old brick building. I walked through the main entrance and then down through a drab, dark, dreary tunnel toward a stream of light. The light led me to the grandstand behind home plate. I walked up the ramp and there it was, in all its natural beauty, an incredible vision of a beautiful, green expanse that took my breath away.

Fenway Park was my baseball home for seven seasons, and although there were many exciting and memorable moments, nothing could top 1967. In that Impossible Dream season, we won the pennant by winning the last game—one of the happiest and most joyful days Fenway Park ever experienced. I was the pitcher that day, and the memories of that day and season have been passed down from grandfathers to fathers and grandmothers to mothers. Those of us who played on that team are afforded an elite place in the history of Fenway Park and the Red Sox. Yet Fenway Park and that day hold a special place in my heart for deeper personal reasons. As I toiled at Fenway Park, 17-year-old Rosemary Feeney was visiting Boston exploring college possibilities. She was staying at the Somerset Hotel downtown and knowing nothing of the Red Sox, Fenway Park, or Jim Lonborg, she was taken by the elation that emanated from Fenway and permeated the city. This joyful experience became a significant factor in her selecting the city of Boston in which to attend college. We met two years later. Today, after six children, six grandchildren, and 41 years of marriage, we remain happy Bostonians, owed, in part, to a magical day at Fenway Park.

Today, Fenway Park provides a wonderful family experience that goes beyond just a baseball game. When I return, I am welcomed by the staff, the ushers, and, most importantly, the fans with a warmth that makes me feel like I am heading into my living room to watch a game. Here's hoping that fans throughout New England, America, and indeed the world will be coming home to Fenway for a long, long time.

—Jim Lonborg
Boston Red Sox, 1965–1971
Cy Young Award, 1967

ACKNOWLEDGMENTS

This project could not have come together without the magnificent energy of so many. We extend a heartfelt thank you to: Jane Winton, Henry Scannell, and the photography staff at the Boston Public Library, for their dedication and professionalism; Jim Lonborg and Bill Buckner, for their time and recollections; Dan Rea, Fenway Park archivist; Josh Rogol of the Brockton Rox; Lynda Fitzgerald, for her eye, perspective, encouragement, and enthusiasm, NFhmyal; Steve Adamson, Steve Bronchuk, and Henry Martyniak whose passion for Fenway and the game proved an invaluable asset; Bill Nowlin, Bob Brady, and Dan Desrochers; John Galvin of Digital Image Fidelity, LLC, Whitman, Massachusetts, for his expert consultation; On Stage Theatre, Abington, Massachusetts, for the use of their studio space; the students and staff at Hanson Middle School, for their encouragement; Ryan Easterling, Lissie Cain, and the staff of Arcadia Publishing, for their patience and professionalism; Carolyn Geisler and Heather Rivero, for holding the fort, and the boys at the ranch, for their energy; baseball reference.com; retrosheet.org; fenwaypark100.org; and the Society for American Baseball Research (SABR) bio-project and all the generous, creative people, past and present, who shared their love for Fenway Park expressed in their photographs. Unless otherwise noted, all images appear courtesy of the Boston Public Library.

INTRODUCTION

On June 24, 1911, businessman John I. Taylor announced his intention to build a new home for the Red Sox on nearly eight acres of land between Ipswich and Lansdowne Streets in the Back Bay section of Boston. Purchasing the land at a public auction in February, Taylor never dreamed that the new structure would remain one of the regions most historic and beloved destinations well into the 21st century. It has become as much a part of Boston's history as the Boston Tea Party, the Boston Massacre, and the Sons of Liberty, and it has joined the Old North Church, the Bunker Hill Monument, and the USS *Constitution* as iconic city landmarks.

In April 2012, Fenway Park turned 100 years old. A century has passed by, and some of the city's most poignant, historic, tragic, and joyous moments have played out on its stage. Curses have emerged, demons have hovered, battles have been fought, legends have been born, heroes have conquered and fallen, hearts have been broken, and "Impossible Dreams" have come true. Five generations of Bostonians have passed through the gates of these hallowed grounds. In the decades of the 1950s and 1960s, little boys were indoctrinated into the world of the Red Sox fan with ritualistic first visits in the company of their fathers and grandfathers. In that era of black and white television, this marked the first living color baseball experience for the baby boomer generation. During the 1970s and 1980s, little girls became just as much a part of the Fenway Park landscape. In the 21st century, "Wally" the friendly, furry "Green Monster" entertains and regales children on the field and in the stands. A foundation of loyal, true Red Sox fans, once dubbed the "Fenway Faithful" by Red Sox broadcaster Ned Martin, has blossomed into a "Nation." In its first century, Fenway has been built and rebuilt, designed and redesigned; it has been burned, it has been scorned; it has been worshiped and adored; and like the toughness of the New Englanders who revere it, it has endured.

The first seven years of Fenway Park brought the most successful stretch in Red Sox history as they won American League pennants in 1912, 1915, 1916, and 1918. In a bit of an historical quirk, the Red Sox did not play their World Series home games in both 1915 and 1916 at Fenway Park, but rather at the brand new Braves Field across town. The two-year-old Fenway Park did, however, see the 1914 World Series as the National League champion Boston Braves played their home series games there.

In its first two decades, Fenway Park played host to scores of football games, most at the high school level, although some college games were sprinkled throughout. Boxing, wrestling, lacrosse, and soccer made their Fenway debuts, as did the circus, political rallies, religious services, and its first concert. Amateur baseball games were regular Fenway events, and even the Braves played most of their home games at Fenway in 1915 while construction on their new field was completed.

The arrival of Thomas Austin Yawkey in February 1933 changed the face of Fenway Park forever. Yawkey, his family, or his trust owned the Red Sox and Fenway Park for the next seven decades. Before his first year ended, an aggressive renovation of the park began. Starting in left field, Yawkey tore down the original 25-foot wall and replaced it with one that was 37-feet high, giving Fenway Park what was to become its signature.

His aggressiveness also fueled a diligent effort to restore the team to respectability, which he did by adding future Hall of Fame players Joe Cronin, Jimmie Foxx, and Lefty Grove. In Yawkey's third year, the club enjoyed its first winning season since they had won the 1918 World Series. By 1938, they were once again contenders. Bobby Doerr, Johnny Pesky, and Ted Williams would be added to the mix, and the Red Sox would remain competitive into the early 1950s. They won the American League pennant in 1946, the first of three they would win under Yawkey. However, they lost the World Series in seven games to the Cardinals. It would take 21 years and a man they called Yaz before they would win again, and in a bit of an ironic twist, that Impossible Dream Red Sox team of 1967 would also drop the World Series in seven games to those very same Cardinals. Yawkey saw one more pennant before passing away in 1976. But once again, his beloved Sox fell a game short, losing in seven games to Cincinnati's Big Red Machine in 1975.

During the first three decades of Yawkey's tenure, football continued as a staple in Fenway's diet of events. In his first year, the Boston Redskins of the National Football League (NFL) became the first professional team other than the Red Sox to call Fenway Park its regular home. By the end of 1948, three more professional football teams had come and gone. The 1950s saw Fenway play home to Boston University and Boston College football. The Boston Patriots moved into Fenway in 1963, becoming its last football tenant, and it has laid football dormant since their departure following the 1968 season.

Politics, religion, boxing, wrestling, and soccer continued to make their way to Fenway for a host of events with Yawkey adding hurling, Gaelic football, and even the Harlem Globetrotters to the menu. And of course, there was more and more baseball with the addition of sandlot tournaments; NCAA playoffs; park league, Catholic Youth Organization (CYO), and high school championships; Old-Timers' games; Cape Cod League All-Star games; and Negro League exhibitions, which included a visit from Satchel Paige and his Kansas City Monarchs.

When John Henry, Tom Werner, and Larry Lucchino purchased the Red Sox from the Yawkey Trust in 2002, they did so amidst talk of a new stadium. They embarked upon a journey of preservation, restoration, and innovation. Fenway's association with amateur baseball has been rekindled, restoring the Cape Cod League All-Star Game and adding baseball's version of the Beanpot Tournament played for bragging rights as the city's top college team. A Futures Day, an annual Fenway doubleheader featuring two Red Sox minor-league affiliates getting a taste of what awaits the worthy, is now celebrated. Music is now an integral piece of the Fenway puzzle, with yearly concerts featuring the biggest and brightest stars of the industry. A host of innovative, interactive festivals and events brings families to Fenway Park to walk and play upon her lawn. And most poignantly, they have opened Fenway's doors to Naturalization Days; thousands of individuals choose Fenway Park as the venue where they are sworn in and become citizens of the United States of America. There is no better place to be welcomed than in one of America's founding cities at the oldest home of America's pastime—Fenway Park.

John I. Taylor, the president of the Red Sox, was largely responsible for the building of Fenway Park in 1911–1912. Taylor's father, *Boston Globe* publisher Gen. Charles Taylor, purchased the team in 1904 from Henry Killilea and turned it over to his son. In September 1911, the Taylors sold half of the stock of the team to James McAleer and Robert McRoy, and McAleer took over as team president. However, it was Taylor who initiated the purchase of land and oversaw the construction of Fenway Park. Taylor also is responsible for naming the facility, which came about innocently enough. When asked about the name, he said simply, "It's in the Fenway, so it will be Fenway Park." It was Taylor who changed the team name from the Americans to the Red Sox following the 1907 season.

One

THE EARLY YEARS

There is no doubt that Fenway Park's left-field wall is its most distinct feature. Now known as the "Green Monster," it did not come into existence until the reconstruction of 1934. The original wall at Fenway was 25-feet high, and at its base was a slight incline of land that ran along its length. A fielder had to literally run uphill to catch or retrieve a baseball. Red Sox left fielder "Duffy" Lewis became so adept at doing so that in Fenway's first year the area became known as "Duffy's Cliff." Construction continued on the park throughout its inaugural season and right up to the 1912 World Series. The Red Sox won 105 games in 1912 (a team record that still stands) and captured their third American League pennant and second world championship. Fenway's first seven seasons saw the Red Sox make four trips to the World Series.

Little was done to the ballpark in its first 20 years. The measurements, at one point, were a staggering 550 feet to the deepest part of the field. It survived fires on successive days in 1926. The left-field bleachers, destroyed by that fire, were not restored and left a scar that was as ugly as the teams' play on the field. In 1928, temporary bleachers were erected to accommodate Boston College football games.

After opening in 1912, it did not take long for Fenway to expand its repertoire. Almost immediately, it featured football, boxing, wrestling, soccer, a few religious services, and political rallies as well as its first, last, and only circus. By the late 1920s, aside from falling into disrepair, it had also watched its Red Sox go from the class of the league to its doormats.

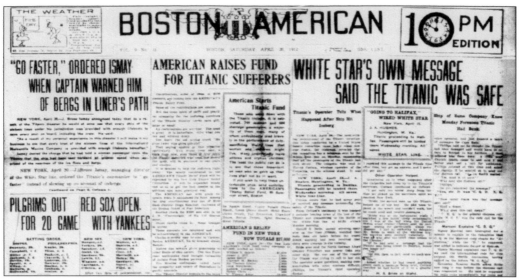

Though the official grand opening of Fenway Park warranted front-page coverage in Boston newspapers, it was overshadowed by an epic, tragic event. Here, the front page of the *Boston American* on April 20, 1912, has a small story to the lower left about the Red Sox's first official game at Fenway alongside several larger articles covering the sinking of the *Titanic*.

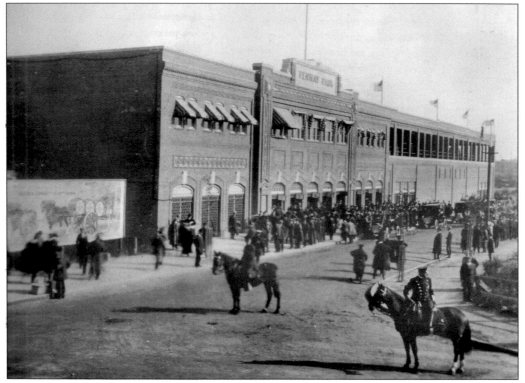

On Fenway Park's first opening day, April 20, 1912, Jersey Street (now Yawkey Way) was filled with fans. As Boston Police patrol the area on horseback, the crowd is set to enter Gate A to watch the Red Sox host the New York Highlanders in the official opener. The Red Sox sent their fans home happy that day by defeating the Highlanders (now Yankees) 6-5 in 11 innings.

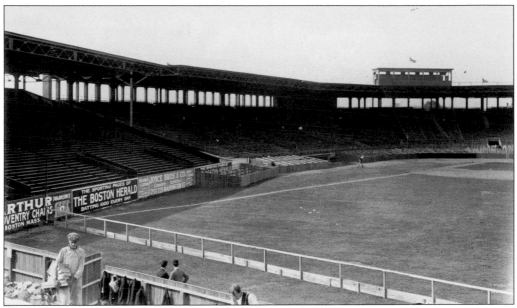

This photograph was taken from the lower section of the right center-field bleachers in September 1912. The original press box behind home plate in the left of the photograph resembles a trolley car sitting on top of the park's roof. Note the advertisements along the short wall in front of the right-field grandstand. Fenway hosted its first World Series the following month.

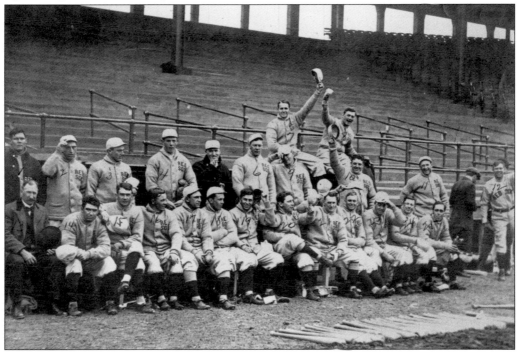

Seated just to the left of the dugout on the first-base side of their brand new ballpark shortly before it opened is the 1912 Boston Red Sox team, who instantly found their new park friendly. The team won 105 games, captured the American League pennant, and defeated the New York Giants in the World Series. Note that many seats in the grandstand had yet to be installed.

This photograph, also from 1912, shows the left-field bleachers and left-field wall. The original structure had an angled embankment of turf that ran along the entire base of the wall, which became known as "Duffy's Cliff." It was named after Duffy Lewis, a Red Sox left fielder from 1910 to 1917 who had mastered play of the embankment. Temporary bleachers are set up there for the upcoming series.

The Red Sox engage in the routine exercise of taking batting practice in their new ballpark in its second season. This photograph is taken from the seats behind home plate, slightly to the first-base side, and shows a good view of the original left-field wall completely covered with advertisements. Note the Red Sox uniforms of that period—simple, plain, and white with no logo on the white cap.

Red Sox and Fenway Park owner Joe Lannin shakes hands with manager Bill Carrigan around 1914. Lannin was born in Quebec in 1866 and moved to Boston as a youth. He became a self-made millionaire by purchasing hotels, golf courses, and other real estate. He bought the Red Sox from James McAleer in late 1913 and Fenway Park from John I. Taylor in May 1914.

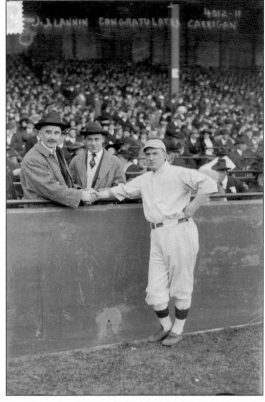

This c. 1914 view is from a vacant lot directly across from Fenway Park's main entrance on Jersey Street (now Yawkey Way). Comparing the general look of the brick facade from then to the early 21st century shows how little it has changed. On the sidewalk directly in front of the building, the newly planted tree (center) now stands as a giant oak tree looming over the facade in 2012.

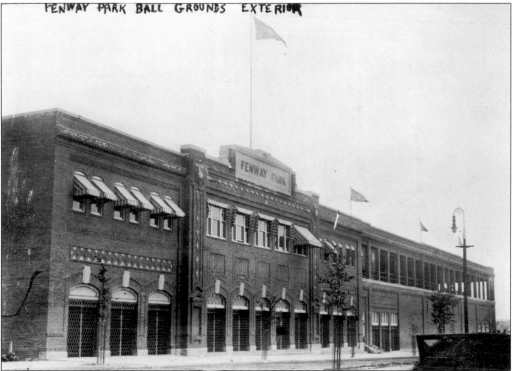

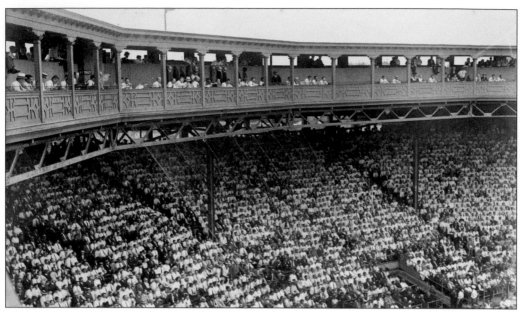

This interesting angle shows the area behind home plate and the ornately designed press box around 1914. In the original structure, the press box consisted of only one section, spanning the width of the screen behind home plate. By 1914, two similar sections were added to both the first-base and third-base sides, bringing the total to five connected sections.

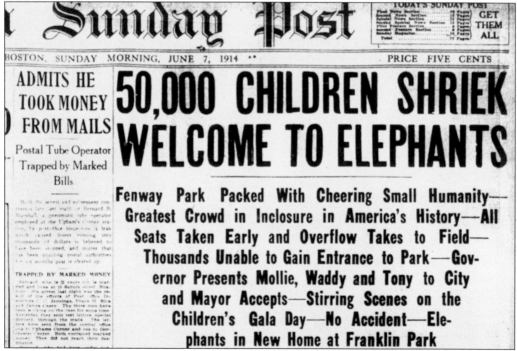

Sunday Post

TODAY'S SUNDAY POST

GET THEM ALL

BOSTON, SUNDAY MORNING, JUNE 7, 1914 •• PRICE FIVE CENTS

ADMITS HE TOOK MONEY FROM MAILS

Postal Tube Operator Trapped by Marked Bills

50,000 CHILDREN SHRIEK WELCOME TO ELEPHANTS

Fenway Park Packed With Cheering Small Humanity— Greatest Crowd in Inclosure in America's History—All Seats Taken Early and Overflow Takes to Field— Thousands Unable to Gain Entrance to Park—Governor Presents Mollie, Waddy and Tony to City and Mayor Accepts—Stirring Scenes on the Children's Gala Day—No Accident—Elephants in New Home at Franklin Park

One of the earliest of the unusual events that took place at Fenway Park was Pennies for Elephants Day on June 6, 1914. Schoolchildren in the Boston area had raised $6,700 by contributing pennies and small change to purchase three elephants for the nearby, newly built Franklin Park Zoo. Upon their arrival, the elephants entertained 50,000 mostly young fans.

16

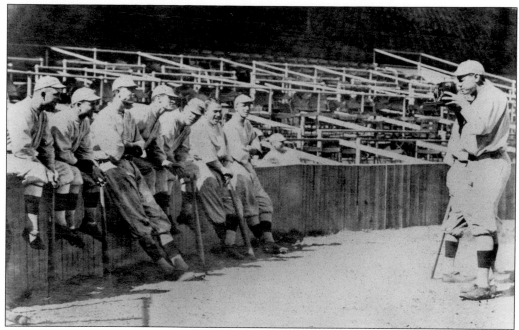

A young Babe Ruth, far right, took a photograph of several of his Red Sox teammates lined up just beyond the third-base dugout around 1915. Ruth, only 20 years old, was becoming a Fenway favorite. By 1916, he emerged as one of the top pitchers in the league and was also starting to show signs of his legendary home run power.

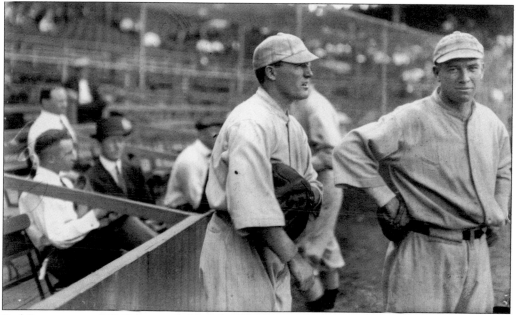

Red Sox manager Bill Carrigan (left) and outfielder Tristram "Tris" Speaker are shown standing near Fenway's grandstand on the first-base side in 1915. Until Terry Francona duplicated the feat in 2007, Carrigan was the only Red Sox manager to preside over two world championships (1915 and 1916). Speaker was the team's biggest star when Fenway Park opened in 1912 and remained so until his trade in 1916.

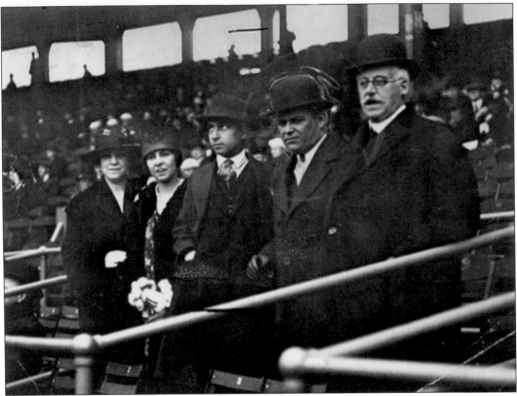

Standing second from right with his family in the owner's box seats at Fenway Park is Red Sox owner Harry Frazee. A producer of Broadway plays, Frazee purchased the team and Fenway from Joseph Lannin in November 1916. Though he presided over a world championship in 1918, he earned the scorn of Red Sox fans for decades for selling Babe Ruth to the Yankees in 1920.

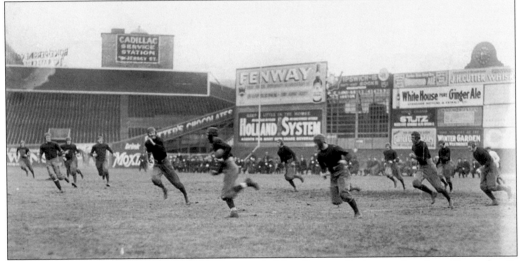

One of the early Boston College football games held at Fenway Park was played on December 2, 1916; the team is shown here playing rival Holy Cross. Boston College had not beaten them in 17 years but would prevail this day by a score of 17-14. Boston mayor James Michael Curley was among a crowd of 8,000 fans.

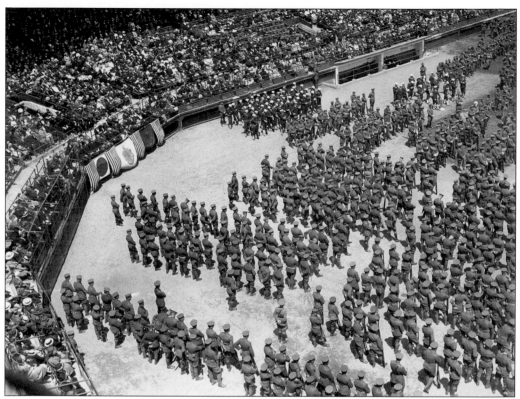

Military masses, such as the one shown here around 1918, occurred on Fenway's infield during this period and for many years after. Generally occurring around Memorial Day, these masses were held in honor of World War I and Spanish-American War casualties. They commonly attracted approximately 30,000 patrons.

This flag-raising ceremony was held in center field in April 1920. Just to the right of the flagpole is Red Sox captain Harry Hooper, Washington Senators manager Clark Griffith, Massachusetts governor Calvin Coolidge, and various dignitaries and military personnel. The flagpole remained on the field of play for many more decades.

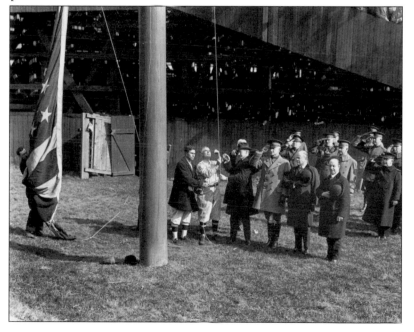

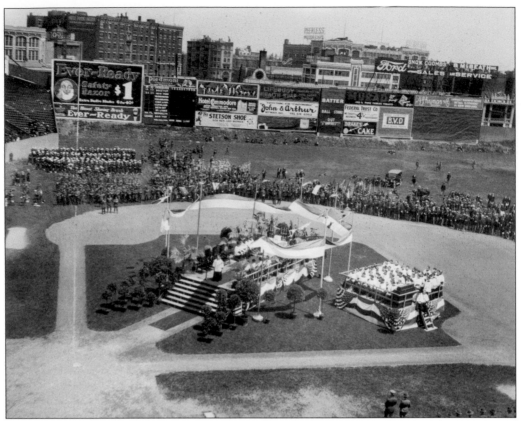

On May 26, 1918, William Cardinal O'Connell, who served as Boston's archbishop from 1907 until his death in 1944, conducted this Memorial Mass for fallen World War I veterans. He returned to Fenway Park in 1934 to celebrate his 50th anniversary as a priest. This photograph gives a good view of the left-field wall and the advertisements it featured at that time.

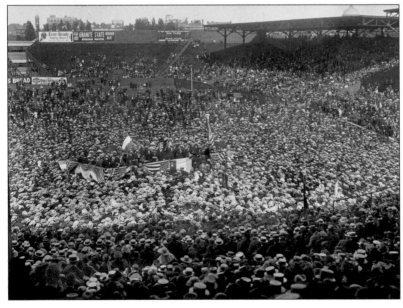

A rally for Irish independence was held at Fenway on June 29, 1919. The featured speaker was Eamon DeValera, who followed a speech by Governor Coolidge. DeValera was the most dominant political figure in Ireland in the 20th century and served as its third president from 1959 to 1973. The rally pictured here drew over 60,000 people.

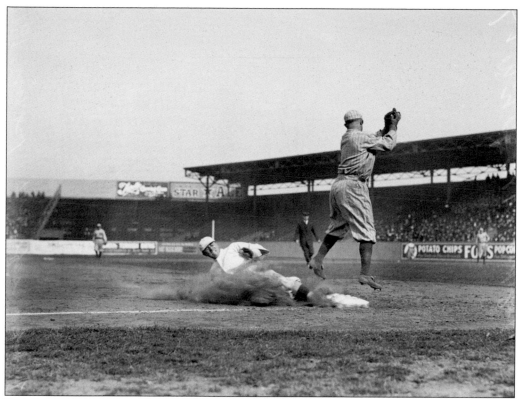

Red Sox outfielder Harry Hooper slides into third during a Fenway game around 1916. Hooper, one of the greatest defensive right fielders to ever play the game, played 12 seasons with the Red Sox and was a highly significant contributor in four World Series championships. The Veteran's Committee elected him into the National Baseball Hall of Fame in 1971.

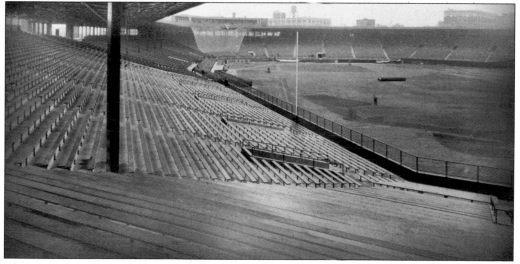

The original structure, as it appeared around 1930, is shown in this photograph taken from the grandstands in the deep, right-field corner. Note that benches rather than seats were used in this portion of the park. The benches were often vacant from the late 1920s through the early 1930s, as the Red Sox averaged less than 4,500 spectators per game.

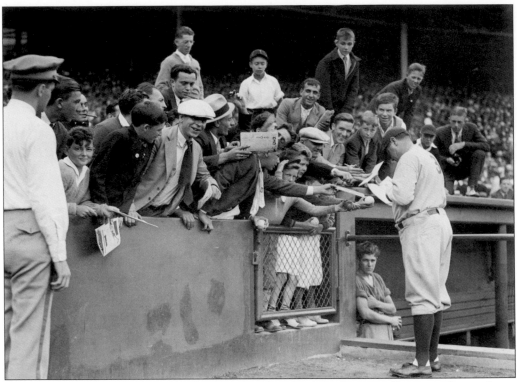

Though he had not worn a Red Sox uniform in a decade, the Babe was still immensely popular to the fans at Fenway. Ruth was beloved by fans everywhere, regardless of the uniform he wore, and here, around 1930, he signs autographs for admirers before a game against his old Boston team.

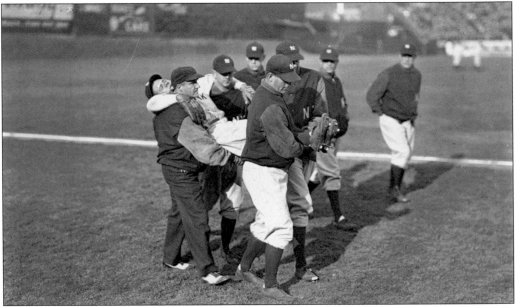

Ruth was carried off the Fenway field by Yankee teammates on April 22, 1931. While playing left field, Ruth ran to catch a high fly ball and collapsed with what was described as a severe charley horse. He was taken to a Boston hospital in a police patrol wagon.

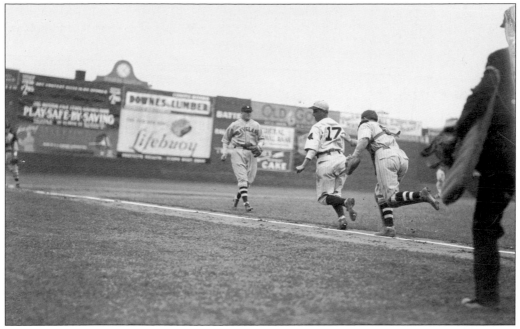

In this game-action photograph from 1931, Red Sox outfielder Al Van Camp is tagged out in a rundown by Cleveland Indians catcher Luke Sewell. Visible upon close inspection is the single red sock on the front of the Red Sox cap, which only appeared that one season—the same season numbers made their debut on the jerseys. Note the mantel-style clock on top of the left-field wall.

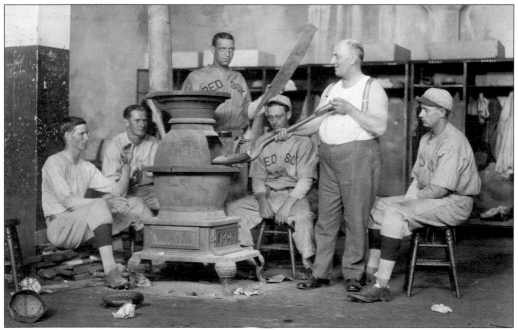

Red Sox trainer Bits Bierhalter, surrounded by Boston players, feeds the potbellied stove in the home team's clubhouse on a cold, spring day in 1929. To Bierhalter's immediate right is pitcher Danny MacFayden and to his left is pitcher Ed "Bull" Durham. While the stove was removed within a few years, the locker room's rather Spartan conditions remained for several decades.

Standing near Fenway's backstop in the spring of 1932 is journeyman outfielder Earl Webb. His main claim to fame in a rather undistinguished seven-year career came in 1931 as his 67 doubles set an all-time, single-season record. Boston baseball writers speculated that as Webb was approaching the record late in the season, he might have slowed down on a few would-be triples to increase his doubles total.

In this scene from Fenway's home clubhouse in 1932, four players sport their newly styled uniforms. Third from left is Marty McManus, an infielder who became player-manager in mid-June that year. The team had the worst record in its history at 43-111 and drew the fewest fans for a season at 162,150.

Two

Yawkey Arrives,
Fenway Changes

From 1912 until 1933, the multipurpose Fenway Park had four different owners. John I. Taylor, Joseph Lannin, Harry Frazee, and Robert Quinn owned the park consecutively throughout that span. By the early 1930s, Quinn's cash-strapped ownership had left the team in shambles and the park badly in need of a face-lift.

All of that changed in February 1933 when Detroit-born Thomas Austin Yawkey purchased the team and Fenway Park for $1.5 million. Yawkey inherited a multimillion-dollar estate in 1919 but was forbidden from taking control of it until he was 30 years old. He bought the Red Sox four days after his 30th birthday, beginning an ownership that lasted even beyond his death in 1976. The Yawkey family and/or trust owned the Red Sox from February 1933 until February 2002, a total of 69 years, the longest tenure of ownership in baseball history.

Yawkey immediately began investing his vast capital on Fenway Park improvements, with his first order of business tearing down "Duffy's Cliff" and the original 25-foot, left-field wall and replacing it with the 37-foot structure that stands today. The new wall was adorned with advertisements until 1947 when Yawkey removed them and had the wall painted green. Pitchers began referring to it as a green monster and the name stuck. By the end of the first decade of his ownership, upgrades and improvements had been made throughout the ballpark. He moved the bullpens from foul territory to their current place in right field, shortening the home run distance from 402 to 379 feet. Done to accommodate the new Red Sox star Ted Williams, the bullpens initially garnered the nickname "Williamsburg." With all of the renovations and changes, the wall has remained Fenway Park's signature.

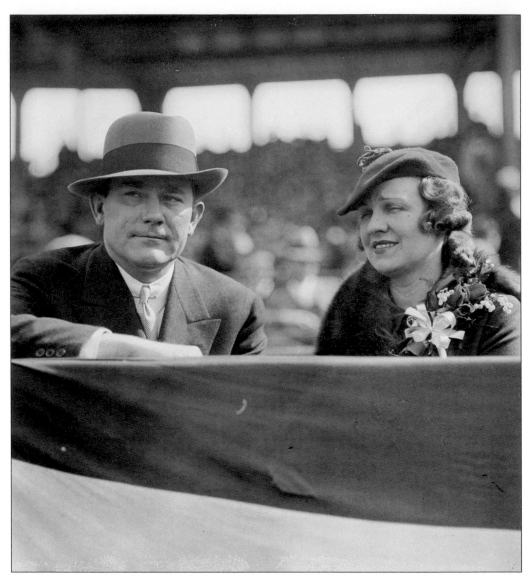

Thomas Austin Yawkey and his first wife, Elise, are shown seated at Fenway Park in the early years of his ownership. Yawkey inherited millions of dollars from his adoptive father, William. Upon his 30th birthday, he immediately purchased the team and park. He wasted no time investing heavily in his passion and did so until his death in 1976. Among his first acts was to hire former great second baseman Eddie Collins as the team's general manager to bring in the best available players, regardless of cost. Yawkey also realized that the 20-year-old Fenway Park was badly in need of a makeover and initiated a massive renovation in 1933. After divorcing his first wife, he married New York model Jean Hiller in December 1944. The couple, having no children, viewed the team and its players as their family. Often on Sundays when the Red Sox played on the road, they would have a picnic on the outfield grass and listen to the game on the radio. Yawkey was elected to the National Baseball Hall of Fame in 1980.

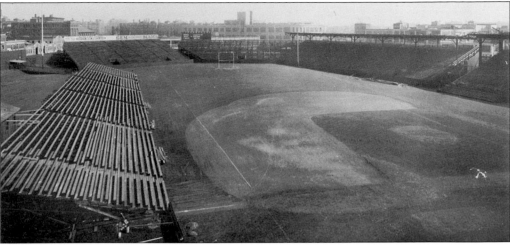

This photograph from September 30, 1933, shows Fenway set up for football. Three days later, the park hosted a high school football doubleheader, with another the following day. Four days later, the NFL's Boston Redskins played their first game at Fenway, beating the visiting New York Giants 21-10. Within weeks, the park was set for a major face-lift.

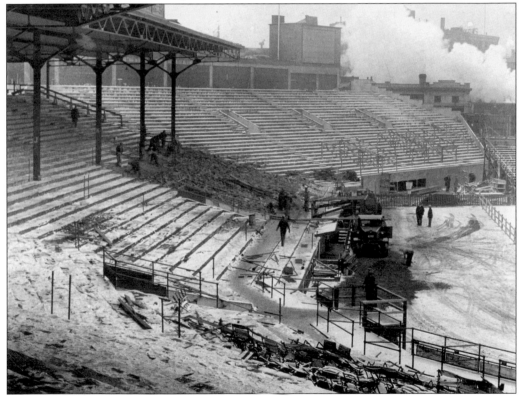

The photograph, taken in the late fall of 1933, looks from behind home plate towards the left-field grandstand. The roof was extended down to the end of the grandstands on both sides, and the playing field was slightly reconfigured, with home plate being moved approximately 10 feet farther out. The total cost of the project was estimated at $1.5 million—a massive figure in the midst of the Depression. (Courtesy of Bostonian Society/Old State House Museum.)

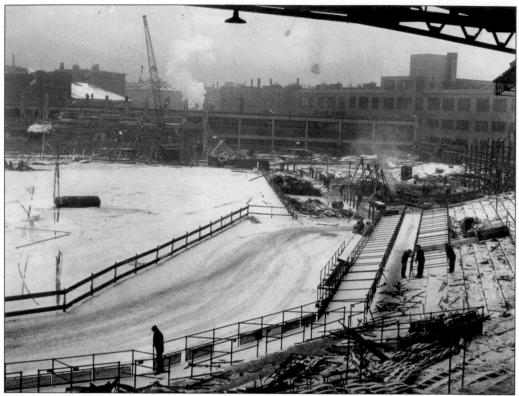

This photograph shows that the complete remodeling of Fenway Park is well under way. With snow on the ground, construction workers toiled through the winter, sometimes with two shifts per day. The above view is from behind home plate looking towards right field. Old wooden grandstands and the bleachers are being replaced by concrete and steel construction. The photograph below, taken on November 27, 1933, from the deep left-field corner, shows the new left-field wall being built, as the temporary football bleachers are still set up for the few remaining high school football games of the 1933 season. (Above, courtesy of Bostonian Society/Old State House Museum.)

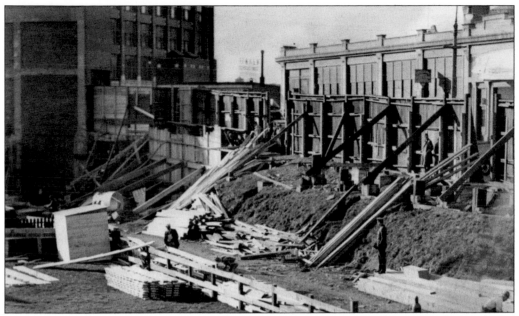

Under the watchful eye of a Boston police officer (standing on lumber right of center), the construction of a new left-field wall proceeds. Though the wall had existed in a slightly different form previous to this construction, upon its completion in 1934 it had the appearance it retains today. The wall and park would also be given its Dartmouth green color. (Courtesy of Bostonian Society/Old State House Museum.)

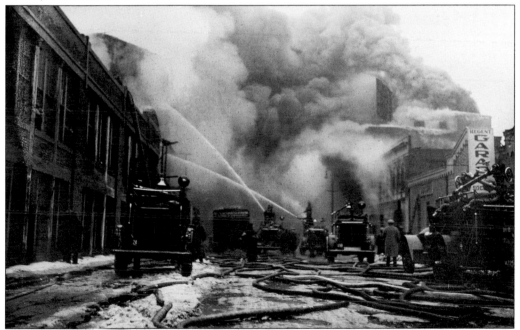

On January 5, 1934, a fire broke out under the center-field bleachers. Though work had been progressing steadily throughout the fall and winter, there was little time to spare in order to finish by opening day. Tom Yawkey then greatly increased the size of the construction crew to repair the damage and complete the job by April 1934.

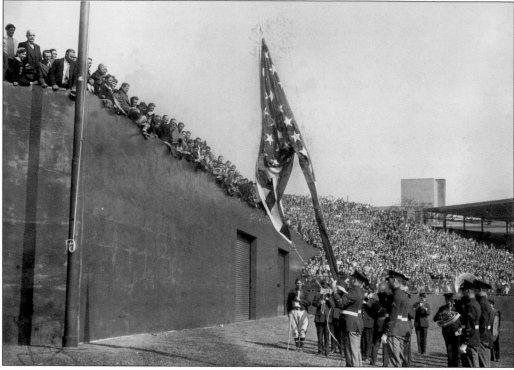

The opening-day flag was raised on April 17, 1934. The photograph clearly shows that the flagpole remained on the field of play, just to the left of the new garage doors in deep center field. Under the flag, dressed in a baseball uniform and tuxedo jacket is Al Schacht, a Washington Senators coach who was also known as the "Clown Prince of Baseball."

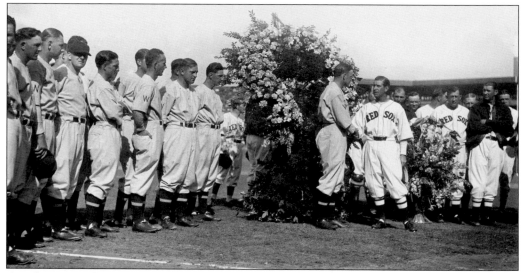

Another scene from opening day shows the newly remodeled Fenway Park in 1934. New Red Sox manager Bucky Harris presents a wreath of flowers to Washington Senators manager Joe Cronin, who had lead his team to the World Series the previous fall. The two managers would switch places after the 1934 season, with Cronin being hired by Tom Yawkey for Boston and Harris taking over the Senators.

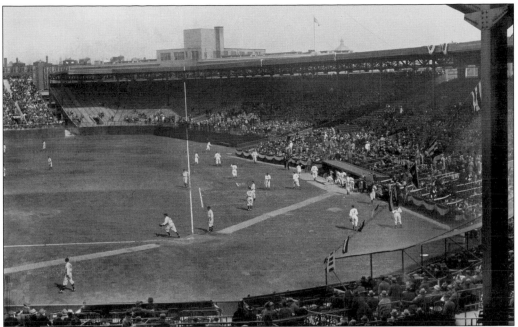

This photograph was taken from grandstand section 24 looking directly down the first-base line on opening day in 1934. The Red Sox were hosting the reigning American League Champion Washington Senators. This was the first official look at the new Fenway Park, and more than 33,000 fans came to see the improvements.

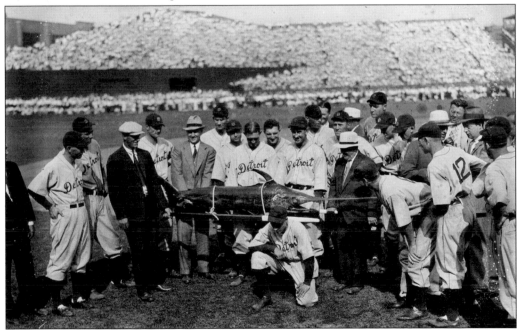

As an overflow crowd packs Fenway on August 19, 1934, a group of fans from the seaside town of Gloucester, Massachusetts, present a swordfish to the Detroit Tigers. The contingent was there to honor Tigers coach Cy Perkins, who was a Gloucester native. The crowd of well over 46,000 is among the largest attendance recorded for a Red Sox game.

Local schoolboy football players enjoy the thrill of playing a game on the same field as the NFL's Boston Redskins. Here, on October 12, 1934, Dorchester High School takes on Mechanical Arts High—one of the more than three dozen games that fall involving Boston-area high schools. Two days after this game, the Redskins beat Pittsburgh 37-0 at Fenway.

Eddie Collins is seated in Fenway's grandstand with two unidentified women around 1935. Collins had been one of the greatest second baseman in history, and he was elected to the National Baseball Hall of Fame in 1939. He and Tom Yawkey were alumni of the same prep school, and when Yawkey bought the Red Sox in 1933, he hired Collins as the general manager, a position he held until 1947.

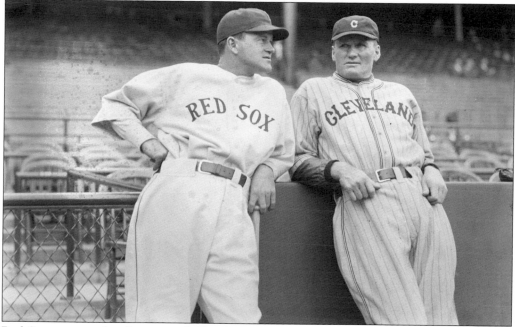

Red Sox manager Joe Cronin and Cleveland Indians manager Walter Johnson chat near the visitor's dugout at Fenway before a game in the spring of 1935. Cronin was in his first year with Boston, and Johnson was in his final season with Cleveland. The following year, Johnson was among the first five men elected to the National Baseball Hall of Fame.

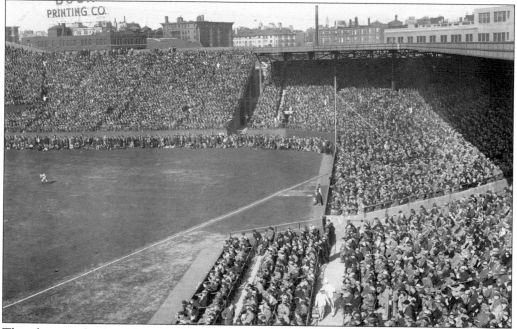

This photograph of a sold out Red Sox game in the 1930s was taken from near the press box area. With every seat in Fenway Park occupied, fans purchased standing-room-only tickets and stood in the outfield against the bleachers. The area far down the right-field line served as the Red Sox bullpen area until the bullpens were constructed in front of the bleachers in 1940.

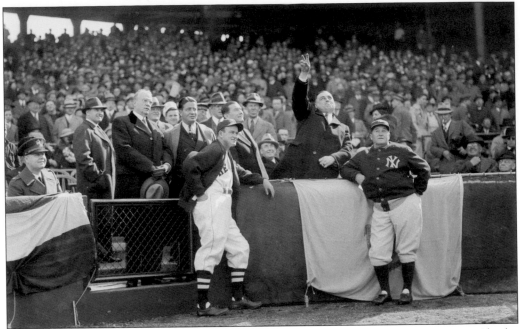

Opening-day ceremonies on April 24, 1937, featured newly elected Massachusetts governor Charles Hurley throwing out the first pitch as Boston manager Joe Cronin and Yankees manager Joe McCarthy look on. Tom Yawkey is standing to Governor Hurley's right. After the 1947 season, McCarthy succeeded Cronin as Red Sox manager.

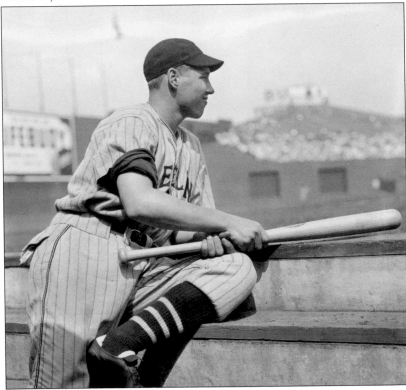

This is 18-year-old Bob Feller on the steps of the visitor's dugout watching the action in 1937. Feller had made his major-league debut the year before right out of high school, and by his early 20s was the premier pitcher in the American League. He started and won the 1946 All-Star game at Fenway Park.

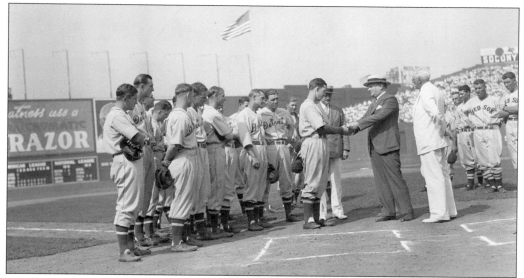

Detroit Tigers catcher George "Birdie" Tebbetts, "the pride of Nashua," is honored by officials of his home state on New Hampshire Day at Fenway Park in August 1937. Tebbetts was a member of the Red Sox from 1947 through 1950. When fans selected the all-time Red Sox team in 1969, he was picked as its catcher.

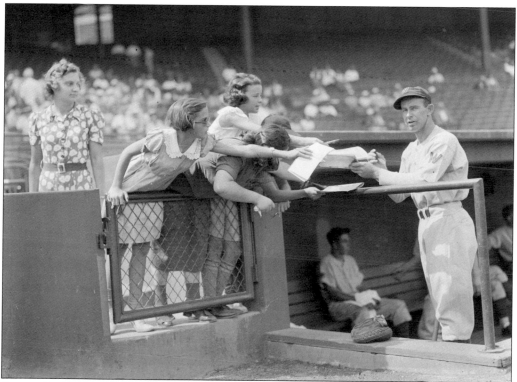

Former Red Sox catcher Rick Ferrell signed autographs for young fans upon his return to Fenway late in the 1937 season. Ferrell and his brother Wes were traded to the Washington Senators on June 11 of that year. The catcher was elected to the National Baseball Hall of Fame in 1984 and added to the Red Sox Hall of Fame in 1995.

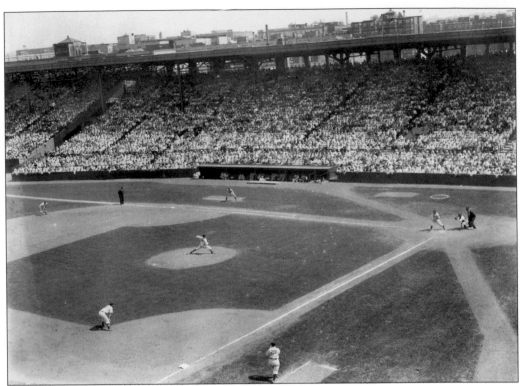

Taken from high in the left-field grandstand in the late 1930s, this image shows a packed Fenway as the Red Sox host the Yankees. Lefty Grove is set to deliver a pitch to Lou Gehrig. It was a golden age of baseball when Boston-area fans witnessed the talents of legendary figures such as Grove, Foxx, Gehrig, and DiMaggio.

Here is Yankee great Lou Gehrig in action at Fenway in the mid-1930s. The Red Sox reportedly passed on a chance to acquire Gehrig early in his career. He hit the first of his major-league home runs at Fenway Park on September 27, 1923, and played 148 games there throughout his career, hitting .350 and driving in 156 runs in those games.

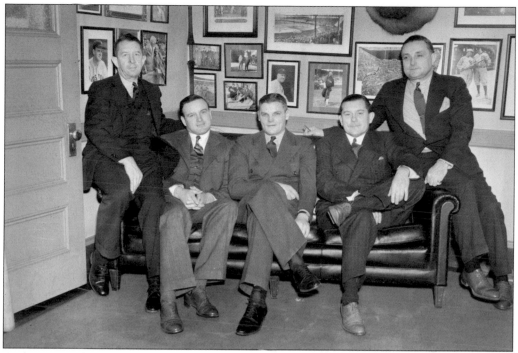

A glimpse of the interior of Fenway Park's executive offices in December 1937 can be seen as Joe Vosmik (center), a star outfielder who had just been acquired in a trade with the St. Louis Browns, arrives. Shown here are, from left to right, Eddie Collins, general manager; Joe Cronin, field manager; Vosmik; Yawkey, team owner; and Billy Evans, minor-league director.

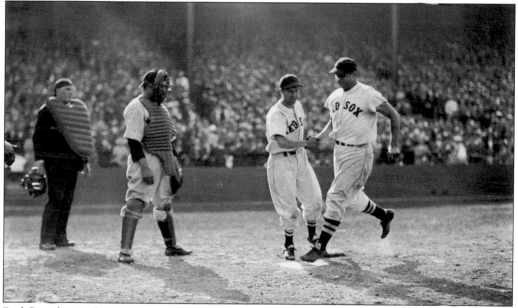

Red Sox slugger Jimmie Foxx crosses home plate in the late 1930s after hitting one of his 534 career home runs. Foxx ranked second all-time in homers behind only Babe Ruth from the early 1940s until the late 1960s. "The Beast" was one of Yawkey's major acquisitions in the early years of his ownership.

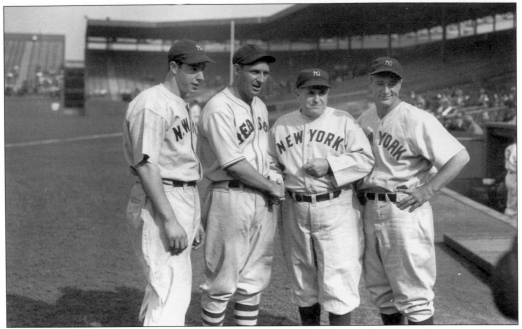

Newly acquired Red Sox outfielder Ben Chapman shakes hands with his former Yankees manager Joe McCarthy on August 11, 1937. Also pictured are Joe DiMaggio, left, and Lou Gehrig, right. This was the first time Chapman played against his former team at Fenway Park, hitting a home run that day.

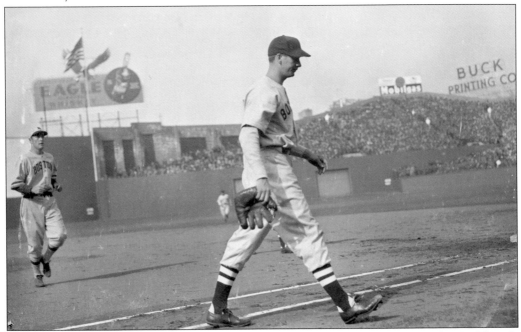

This is a snapshot of a Red Sox-Braves City Series game, which took place in April 1939. Though the two teams never met in a World Series, they played a brief exhibition series just before opening day annually for many years as natural city rivals. This particular series saw Ted Williams play his first game in the city of Boston. Note the Red Sox players wearing road uniforms at Fenway.

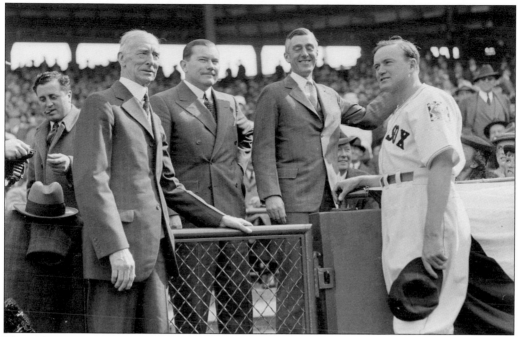

Massachusetts governor Leverett Saltonstall is set to engage in 1939 opening-day ceremonies for the first time since his recent election. Pictured are, from left to right, Connie Mack, manager of the Philadelphia Athletics; Tom Yawkey; Saltonstall; and Joe Cronin. Visible on Cronin's left sleeve is Major League Baseball's 1839–1939 Centennial patch. This was Ted Williams's first official game at Fenway Park, playing center field that day.

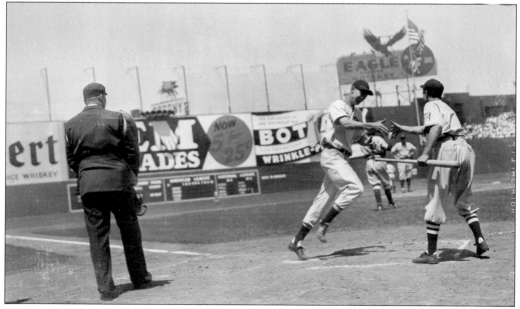

A grinning 20-year-old rookie Ted Williams crosses home plate after hitting a home run against the Yankees in 1939. Williams showed signs of the greatness to come by hitting 31 home runs and driving in 145 runs that year. Five of his homers in 1939 came against the Yankees at Fenway, where he hit .367 in his nine games against Boston's chief rivals.

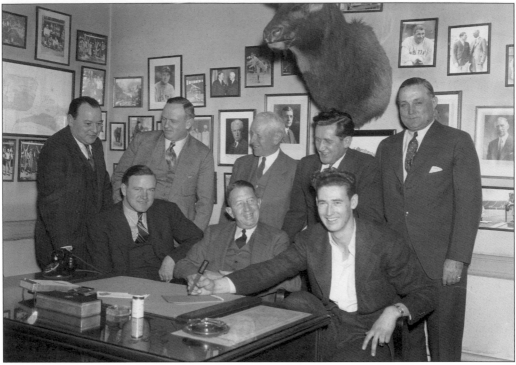

A young Ted Williams is seated in Fenway's executive offices with members of Red Sox management around 1940. Eddie Collins, seated next to Williams, had discovered him while on a scouting trip to the West Coast in 1937. Note the office is decorated with baseball photographs and a buck's head, very likely bagged by Tom Yawkey on a hunting trip.

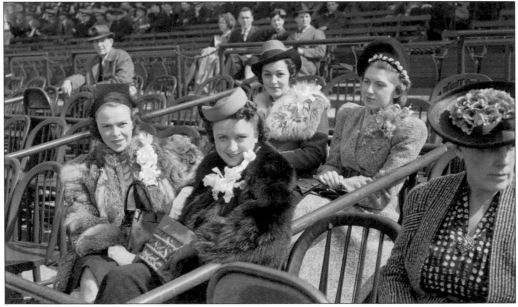

Three-time Olympic champion Sonja Heinie (first row, center) attends a game at Fenway in the 1940s. The Norwegian skater was a 10-time world champion and also had considerable success later as a star in American films. Note the movable wooden seating in Fenway's box seat section.

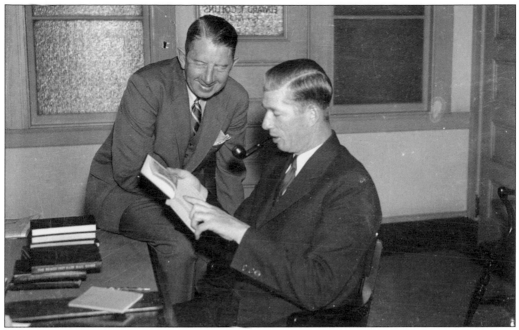

Lefty Grove, smoking a pipe, is with Eddie Collins in the general manager's rather modest looking office around 1940. The great southpaw is perusing the published results of the previous season. Although his career was winding down in 1939, Grove led the American League in earned run average for the ninth time.

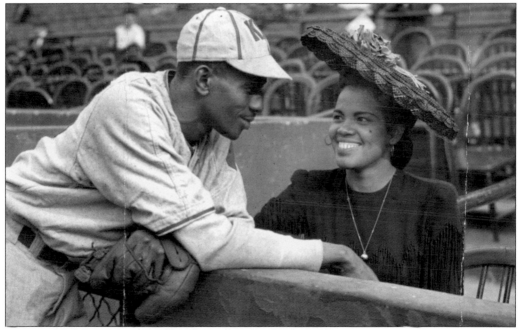

Legendary pitcher Leroy "Satchel" Paige chats with his wife, Lucy, at Fenway Park in 1943. Paige was touring with the Kansas City Monarchs, one of the great teams of the old Negro Leagues who played an exhibition game against a Boston-area team known as The Fore. Tom Yawkey opened Fenway to Negro League teams in 1942.

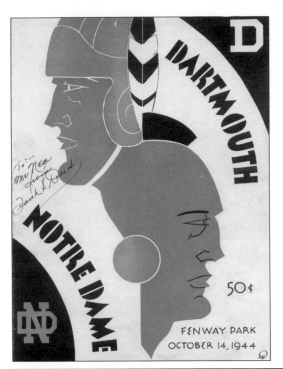

The highlight of the college football schedule at Fenway Park in 1944 came on October 14 as Dartmouth College hosted Notre Dame. Although Ivy League Dartmouth was from nearby Hanover, New Hampshire, Notre Dame was extremely popular among many Boston-area Irish Catholics. Clad in their Kelly green jerseys, the Fighting Irish embarrassed Dartmouth 64-0.

In an aerial view of the Back Bay section of Boston around 1945, the one landmark that becomes instantly recognizable is Fenway Park. Nestled tightly into Boston's Back Bay, it is surrounded by streets on five sides. Visible just below Fenway is Kenmore Square, where Commonwealth Avenue and Beacon Street intersect, the location of many Boston University buildings.

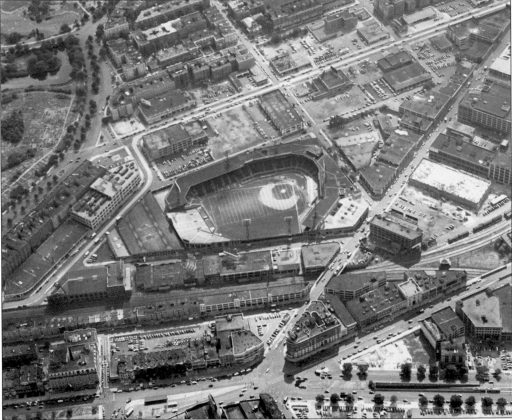

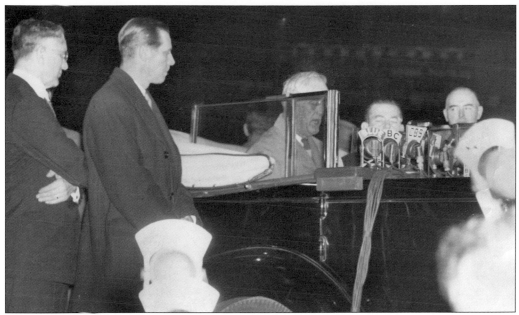

Political history was made at Fenway Park on November 4, 1944, when Pres. Franklin Roosevelt spoke at a Democratic rally. A podium was constructed in the center of the infield and included a special ramp so the president could speak from his car. This marked the last campaign speech ever made by FDR. He was reelected to an unprecedented fourth term three days later and passed away on April 12, 1945.

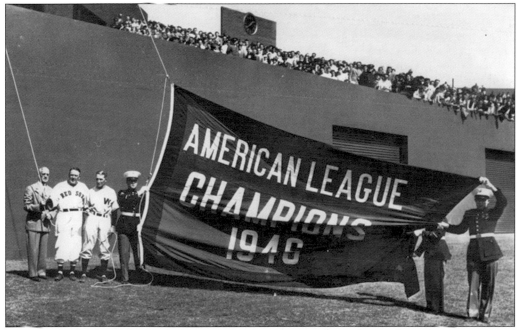

On opening day in 1947, the Red Sox were able to do something they had not done in 28 years. American League president Will Harridge (left) raises the 1946 American League Championship banner assisted by Red Sox manager Joe Cronin. Standing to Cronin's left is Washington Senators manager Ossie Bluege.

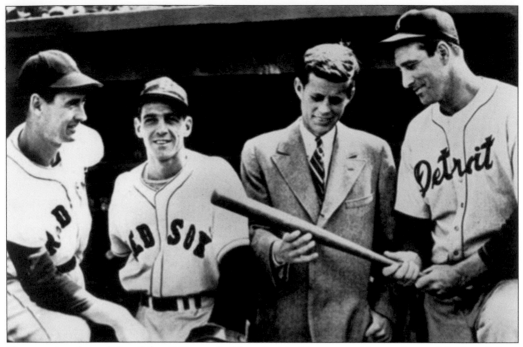

Congressional candidate John F. Kennedy (above) visits Fenway and is seen here with, from left to right, Ted Williams, Eddie Pellagrini, and Tigers star Hank Greenberg in April 1946. At the time, JFK was running for the Democratic nomination in Massachusetts's 11th congressional district. He won the primary in June and was elected to Congress later in November. Kennedy served six years in Congress and eight in the Senate before being elected president in 1960. In April 1964, just five months following his death, his brother and attorney general Robert Kennedy (below) threw out the first pitch on Fenway's opening day. Joining him are, from left to right, Sen. Ted Kennedy, Gov. Endicott Peabody, Stan Musial, and Patricia Kennedy Lawford. The proceeds from this game went to the newly formed John F. Kennedy Library fund to honor the fallen president.

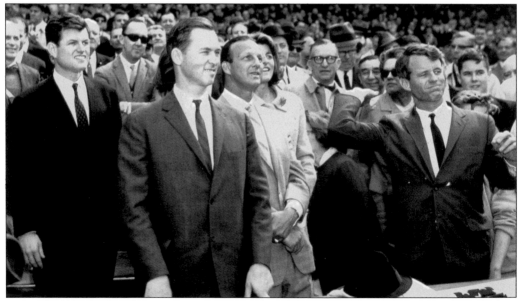

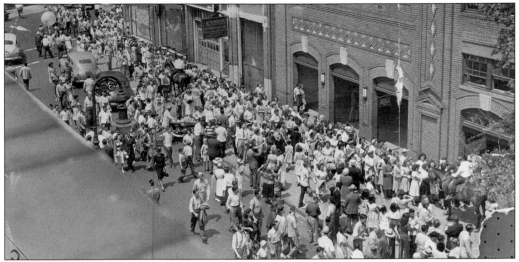

This scene is just before a game against Detroit in which a promotion known as "Ladies Day" was being held. This photograph was taken from atop a building on Jersey Street directly across from Fenway Park's main entrance in 1946 as ladies entered the park for free. With World War II finally over and the Red Sox winning the 1946 pennant, they nearly doubled their previous attendance record, exceeding 1.4 million.

A view from behind the visitor's dugout in very early 1947 shows the new, permanent lights just installed, allowing the Red Sox to play night games. The advertisements on the left-field wall, a feature since the park opened in 1912, would be removed before the start of the 1947 season. Note the NFL's Boston Yanks home schedule is still on the wall.

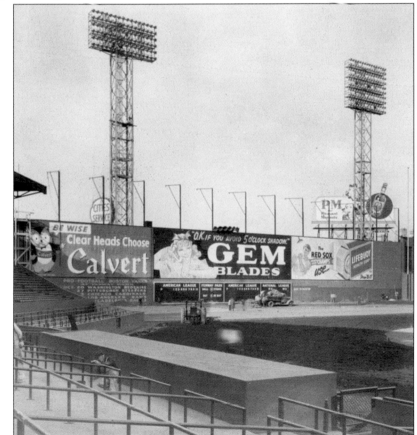

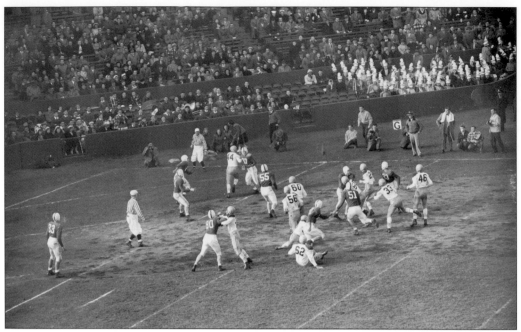

Here is a Boston University football game taking place at Fenway on an autumn afternoon in 1949. BU shared Fenway as its primary home field with the NFL's Boston Yanks in 1948 and continued to use the park regularly until they took over Braves Field in 1953 after the Braves moved to Milwaukee.

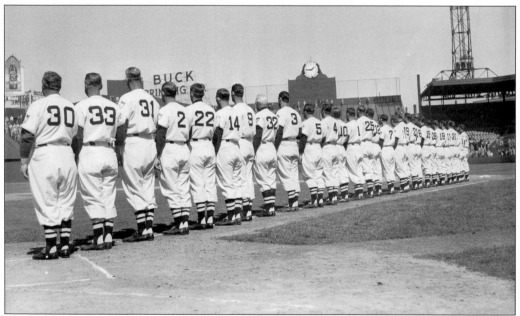

The 1951 Red Sox are lined up along Fenway's first-base line as the familiar Buck Printing Co. sign looms over the center-field bleachers. The American League 50th anniversary patch that was worn on the left sleeve of that year's uniform is clearly visible. Ted Williams, standing seventh from left, was entering his last full season before reentering the military to serve during the Korean Conflict.

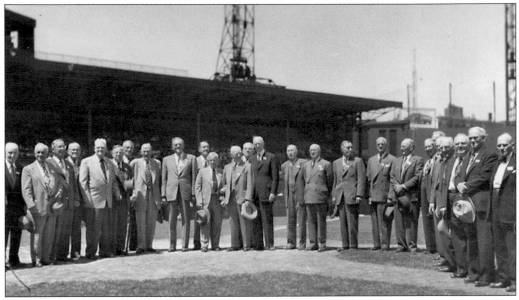

This is a ceremony at Fenway honoring the 50th anniversary of the American League on May 15, 1951. Although he never pitched at Fenway Park, baseball's winningest pitcher, Cy Young, eighth from left, was a member of the Red Sox during their first eight seasons. Legendary manager Connie Mack, who had managed the Philadelphia Athletics for their first 50 years, is in the center in the dark suit.

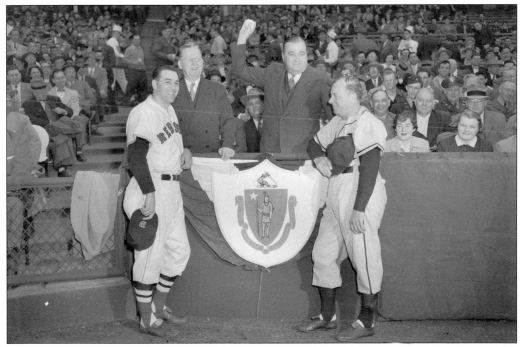

As Fenway was set to celebrate its 40th anniversary, the Red Sox engaged in opening-day ceremonies on April 18, 1952. Massachusetts governor Paul A. Dever throws out the first pitch while new Boston manager Lou Boudreau and Philadelphia Athletics skipper Jimmy Dykes look on. Boston mayor John W. Hynes stands to Dever's right.

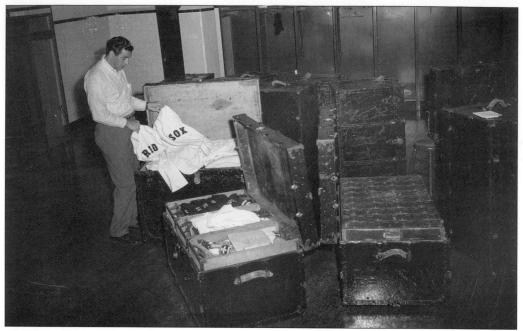

This is Red Sox clubhouse attendant Vince Orlando in the home team's locker room in the early 1950s. He is engaged in the arduous process of packing the trunks for the long trip to the Red Sox spring training home in Scottsdale, Arizona. Note the austere clubhouse devoid of luxuries and amenities.

Red Sox players Vern Stephens (left) and Walt Dropo share some time with the ladies before a Fenway Park game. Stephens, acquired in a deal with the St. Louis Browns, which included seven players and $310,000 of Tom Yawkey's money, played five seasons with Boston and was an all-star four times. Dropo was the first Red Sox player named Rookie of the Year, accomplished in 1950.

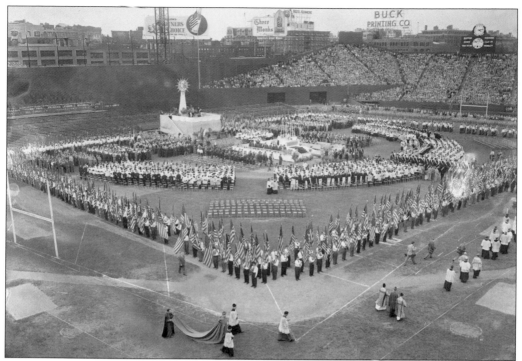

Richard Cushing was the archbishop of Boston from 1944 until his death in 1970. Elevated to cardinal in 1958 and a close personal friend of the Kennedy family, he gained international recognition delivering the invocation at Kennedy's inauguration and conducting his funeral mass in 1963. In this photograph, Fenway Park, lined for football, served as a church as Cushing (at bottom in cape) presided over the services.

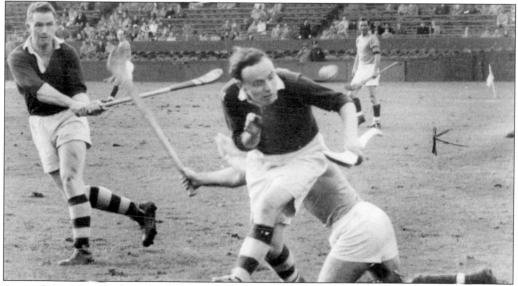

An Irish hurling match took place at Fenway Park on November 7, 1954. Hurling is the national sport of Ireland with origins dating back 3,000 years. Here, the championship Cork team, led by the sport's greatest player, Christy Ring, played the New England All-Stars. Hurling had first been played at Fenway at an Irish field day back in September 1916.

49

The Red Sox are lined up for opening-day ceremonies at Fenway on April 14, 1955, as they prepare to host the New York Yankees. Mike Higgins, wearing No. 5 for the Red Sox, is managing his first game at Fenway Park. Yankee manager Casey Stengel, No. 37, is first in line on the third-base side.

The Red Sox take batting practice just before the gates open to start the 1955 season. Boston defeated New York 8-4 with outfielder Jimmy Piersall hitting a home run. Three years later, Piersall's life story was featured in the movie Fear Strikes Out with many scenes depicted as taking place at Fenway.

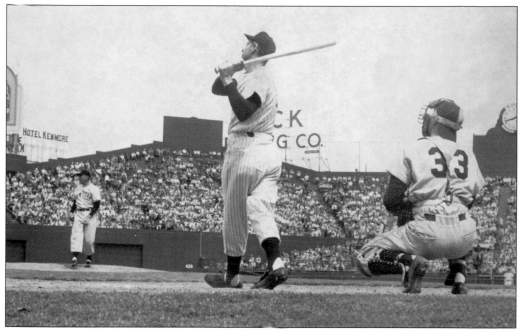

The Fenway stands are full in the summer of 1955 to watch an Old Timers' game featuring many greats from baseball's past. Here, newly elected Hall of Famer Joe DiMaggio faces former New York Giants great Carl Hubbell as Mickey Cochrane assumes his old catching position. Hubbell and Cochrane were both inducted into the National Baseball Hall of Fame in 1947.

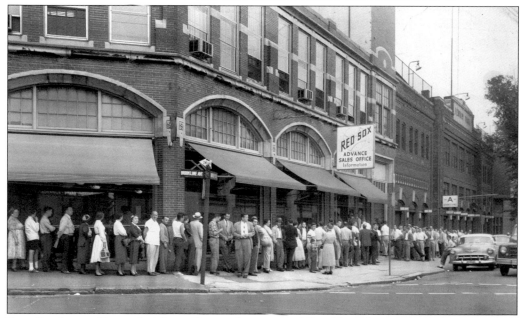

Fans lined up at Fenway's ticket office at the corner of Brookline Avenue and Jersey Street on September 1, 1955. Despite having lost in Chicago the previous two days, pennant fever was gripping Boston as the team was entering September just five games out of first place. They ended the season 12 games behind the pennant-winning Yankees. Fenway's advance ticket office is still at the same location.

A summer crowd gathers outside Fenway for a game in 1956. They could have witnessed Mel Parnell's no-hitter against the White Sox on July 14 or perhaps Ted Williams's 400th career home run three days later. Regardless, they were a portion of the 1,137,158 members of the Fenway Faithful who spun the turnstiles in 1956, the second highest attendance in the American League.

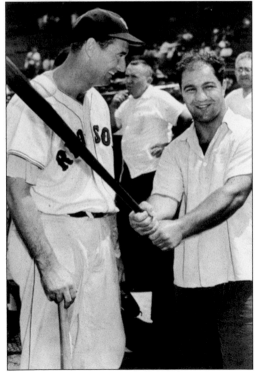

Two extremely distinguished Boston sports champions share a laugh at Fenway around 1958. Rocky Marciano (right), who hailed from Brockton, Massachusetts, had recently retired as the world heavyweight boxing champion with a 49-0 record. Williams was on the verge of winning his sixth American League batting championship in 1958.

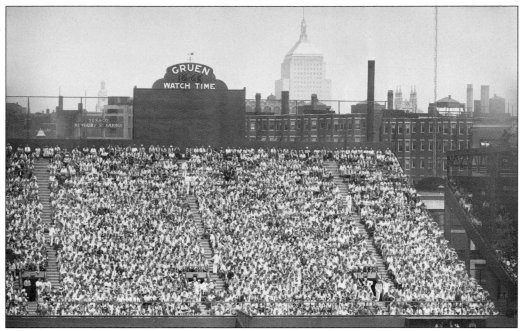

The bleachers are packed for opening day in 1960, marking the beginning of Ted Williams's final season as an active player. Visible behind the bleachers, just to the right of the clock, is the old John Hancock building. There was a weather beacon on its top that flashed red, notifying prospective patrons if that day's Red Sox game was cancelled.

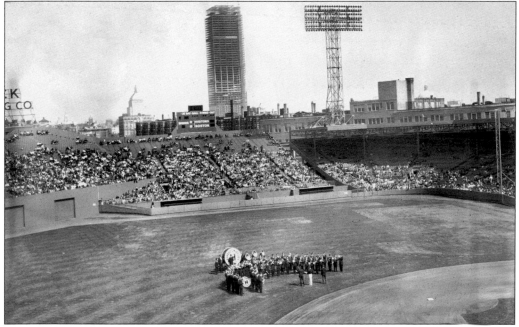

This photograph was taken from the rooftop on the third-base side as the Red Sox are set to open the 1963 season against the Orioles. The Harvard University band supplied the music for the occasion. Under construction in the background, the Prudential tower opened the following year, becoming the tallest building in Boston.

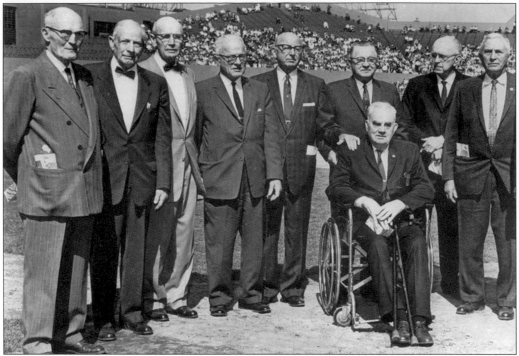

In honor of the 50th anniversary of both Fenway Park and the 1912 World Champion Red Sox team, several players gathered on the field in the spring of 1962. Shown are, from left to right, Bill Carrigan, Steve Yerkes, Joe Wood, Larry Gardner, Duffy Lewis, Olaf Henriksen, Ray Collins (seated), Hugh Bedient, and Harry Hooper.

Fenway is set up for football in 1963—the first year the Boston Patriots played at Fenway Park after moving from Boston University's Nickerson Field (site of old Braves Field). To the left, bleachers are set up in front of the left-field wall. Behind right field, the Prudential building is nearing completion.

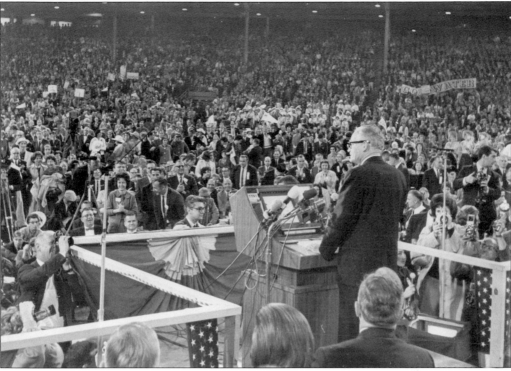

Republican presidential candidate and Arizona senator Barry Goldwater spoke before 20,000 supporters at Fenway Park in September 1964. Massachusetts Republican senator Leverett Saltonstall introduced Goldwater. It was Goldwater's only campaign appearance in the state, which went to Lyndon Johnson in the November election with 76 percent of the vote.

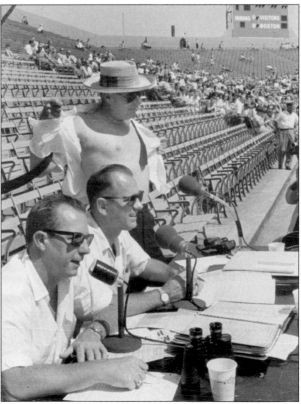

The Red Sox broadcast team in 1965 engages in the novelty of calling a game from a makeshift booth in the center-field bleachers. Pictured from left to right are Ned Martin, Mel Parnell, and Curt Gowdy (standing with hat on). Martin was a Red Sox broadcaster from 1961 through 1992, Parnell pitched 10 seasons for Boston, and Gowdy was among the greatest sports broadcasters of his era.

Carl Yastrzemski lines a two-run single in the fifth inning of the final game of the 1967 season, tying the Twins at two. "Yaz" went an incredible seven for eight the last two games to lead the Red Sox offense on the way to the 1967 Triple Crown, the last player to do so. Below, Red Sox pitcher Jim Lonborg is being carried aloft by jubilant Red Sox fans as the team prevailed in a 5-3 win. The victory capped the "Cardiac Kids" Impossible Dream season and captured Boston's first pennant in 21 years. In the foreground, catcher Elston Howard makes his way toward the Red Sox dugout while first-base coach Bobby Doerr stands close behind "Gentleman Jim." Ken "Hawk" Harrelson emerges from the crowd on one of Fenway Park's most jubilant days.

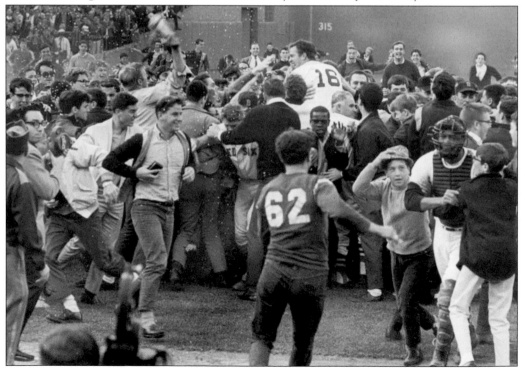

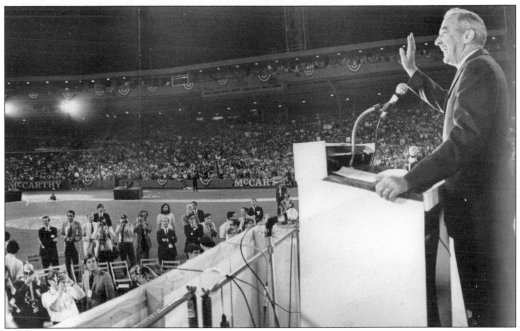

In July 1968, just weeks removed from the assassination of Robert Kennedy, Democratic presidential candidate Eugene McCarthy appeared at a rally at Fenway Park. A crowd of over 40,000 jammed Fenway, more than it had seen in decades. Introduced by Leonard Bernstein, McCarthy received several standing ovations and raised $30,000 simply by soliciting the enthusiastic crowd.

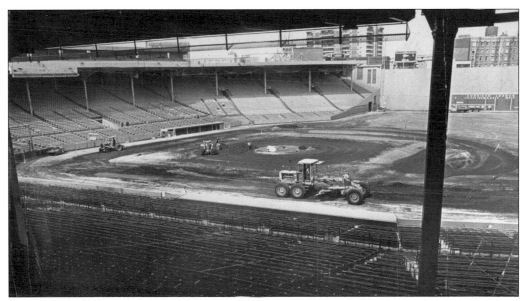

A sight not commonly seen at Fenway—a tractor and other heavy equipment treads on its hallowed ground early in 1969. The photograph was taken from grandstand section 14, down the first-base line, as a new infield is being installed. With the advent of baseball expansion, two new teams came to Fenway for the first time—the Kansas City Royals and Seattle Pilots, now the Milwaukee Brewers.

This photograph was taken from left-field grandstand section 32, looking towards deep center field, after the 1975 season. Staging is set up on the warning track in left field as the wall is being completely resurfaced. Up on top of the deep center-field bleachers, a $1.5-million, 40-by-24-foot Jumbotron scoreboard is being built.

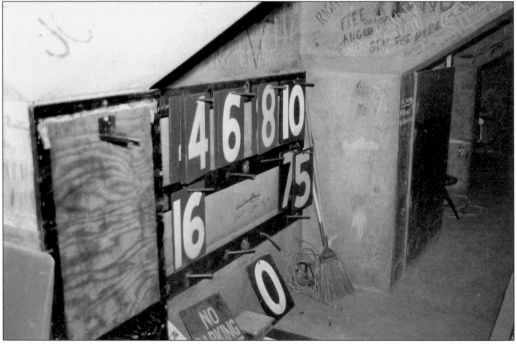

This is a view from deep within the catacombs of the left-field wall where the only manually operated scoreboard in major-league baseball is controlled. The numbers are 16 inches by 16 inches and weigh three pounds. Recent operators Dave Savoy, Jim Reid, and Billy Fitzgerald endured temperatures over 100 degrees inside on hot summer days with no air-conditioning. On the wall, the signatures of many players are visible. (Courtesy of Paul Locke.)

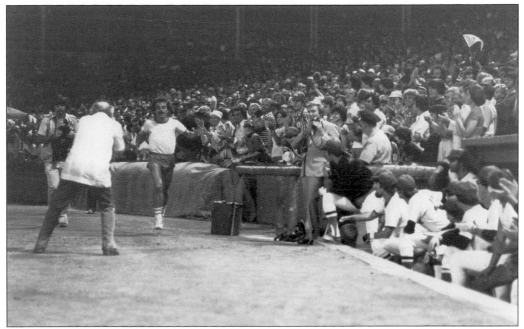

Dave McGillivray from Medford, Massachusetts, is just completing his run from Fenway Park to Hopkinton (starting place of the Boston Marathon) and back during a Red Sox game in 1978. Weeks prior, McGillivray had finished running from Medford, Oregon, to Medford, Massachusetts, raising money for the Jimmy Fund. (Courtesy Dave McGillivray.)

A view from the center-field bleachers shows the newly constructed 600 Club built above the press box area in 1989. The addition created 600 new theater-style premium seats behind Plexiglas, giving this area of the park an entirely new look. Also created was a new press area and broadcast booths. (Courtesy author's collection.)

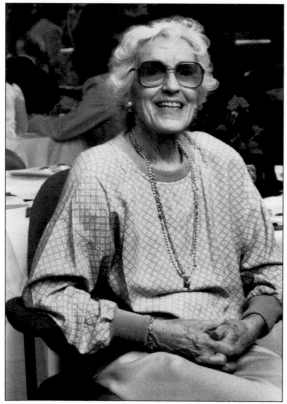

The first renovation that Thomas Austin Yawkey embarked upon when he bought the team in 1933 was the construction of the left-field wall. When it was decided following the 1946 season that the wall would no longer hold advertisements, Jean Yawkey suggested it be painted green. The Yawkeys remain part of the wall with their initials TAY and JRY marked in Morse code on its scoreboard. (Courtesy of Quinn Rhodes.)

Jean Yawkey, wife of Tom from 1944 until his death in 1976, is pictured here around 1985. Jean had a great affection for baseball and upon her passing in 1992 may have been present for more Red Sox games at Fenway than any other person. She remained actively involved in ownership until her death and devoted much of her time to charitable endeavors, including the Jimmy Fund.

Three

WORLD SERIES, PLAYOFFS, AND ALL-STAR GAMES

The 26 World Series games in which the Red Sox have participated at Fenway Park comprise but a minuscule percentage of all of the games they have played there. Since the inception of the major leagues' all-star game in 1933, Fenway has been its host but three times. Yet within those 29 games has emerged some of the most memorable, electrifying, emotional moments in the century-long history of this revered and venerable edifice.

When Fenway Park opened its doors in 1912, the Red Sox won their third American League pennant. Although they have won 10 American League pennants since Fenway's construction, only nine World Series have taken place there. In 1915 and 1916, the Red Sox played their home series games a mile away at the new Braves Field, while the 1914 Braves used Fenway in their World Series against the Philadelphia Athletics.

The three all-star games were played in 1946, 1961, and 1999. The American League won the 1946 and 1999 games and the 1961 contest brought the first tie game in all-star history. Ted Williams was the focal point of the 1946 game and again in 1999 when, at the age of 80, he provided the Fenway crowd and Major League Baseball with one of its most magical, poignant, warm, and heartfelt moments in its history.

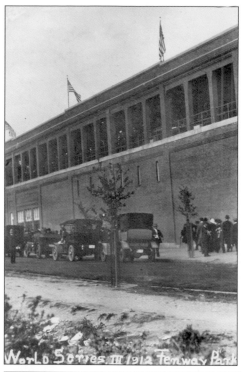

Fans make their way to Fenway Park on Jersey Street, now Yawkey Way, to witness the 1912 World Series. It marked the Red Sox first appearance in a World Series since the inaugural Fall Classic in 1903. Automobiles are beginning to replace horse-drawn carriages along Jersey Street as excited patrons arrive for the event. (Courtesy of baseball-fever.com.)

Fans in Fenway's left-field grandstands watch the first ever World Series game played there in 1912. Note the scoreboard on the original left-field wall, under the Lowney's Chocolates advertisement, denoting the score. The Red Sox scored three unearned runs in the bottom of the first inning. The scoreboard lists Boston on top, even though they batted last. This game ended 6-6, called due to darkness.

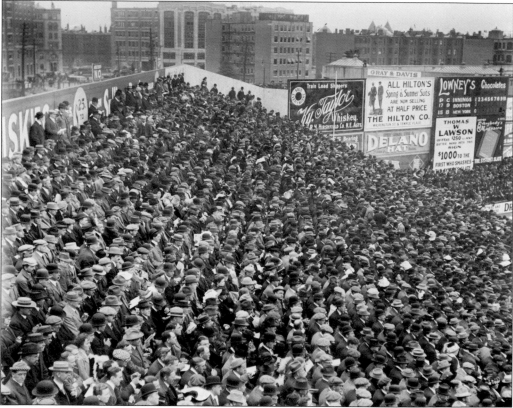

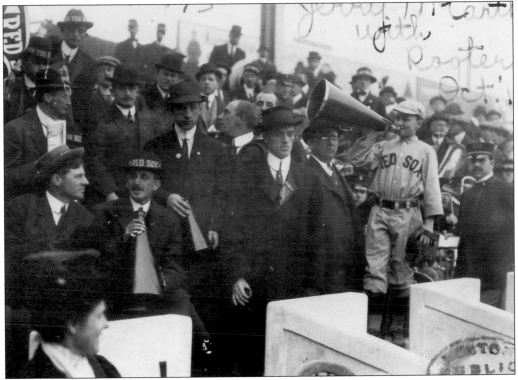

The Royal Rooters, founded by saloon owner "Nuf Ced" McGreevy in 1903, carried over to the new Fenway Park. A raucous band of fans, they played a major role in the Red Sox story. Disbanded in 1918, they were resurrected in 2007 when the Boston band Dropkick Murphys covered their theme song *Tessie*. Here, Rooters mascot Jerry McCarthy cheers on the Red Sox with the boys.

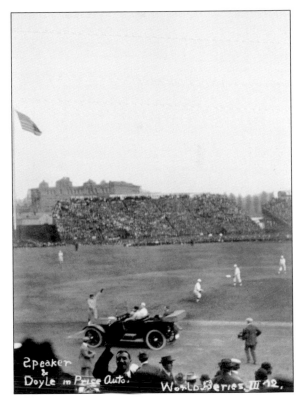

Tris Speaker takes a spin around Fenway Park prior to World Series Game 3. In a pregame ceremony, Speaker was awarded a brand new Roadster for winning the American League 1912 Chalmers Award, an early version of the MVP Award. Along for the ride is Giants second baseman Larry Doyle, the National League winner. The award was instituted by the Chalmers Automobile Company but lasted only four seasons. (Courtesy of baseball-fever.com.)

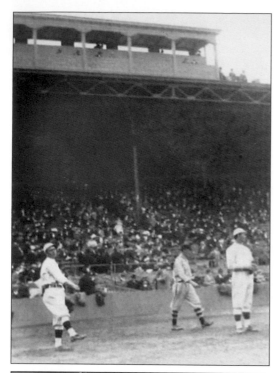

"Smokey" Joe Wood (right) is seen glancing toward the Fenway Park outfield before Game 4 of the 1912 World Series. Wood was the ace of the Boston staff in 1912 with an astounding 34-5 record. His 34 wins, 10 shutouts, 16 consecutive wins, and .872 winning percentage remain records for a Red Sox starting pitcher in a season. He was 3-1 in the 1912 World Series. The Red Sox catcher, at far left, is Hick Cady. (Courtesy baseball-fever.com.)

Members of the Red Sox are assembled in front of Fenway's home team dugout before a game during the 1912 World Series. Standing in the back row is the young daughter of Boston star pitcher Joe Wood, who is seated directly to her left. Seated to her right is superstar center fielder Tris Speaker. Several players in this photograph would gather on Fenway's field for a ceremony 50 years later. (Courtesy of Steve Adamsom.)

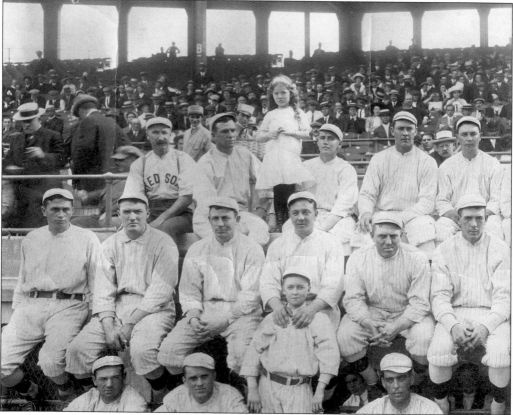

Giants great Christy Mathewson playfully takes batting practice swinging lefty before his start in the second game of the 1912 World Series at Fenway Park. Giants manager John McGraw had held his ace until Game 2, feeling him better suited to handle the "hostile" Boston crowd. "Matty" pitched 28 2/3 innings in the series with a 0.94 ERA yet went 0-2. (Courtesy baseball-fever.com.)

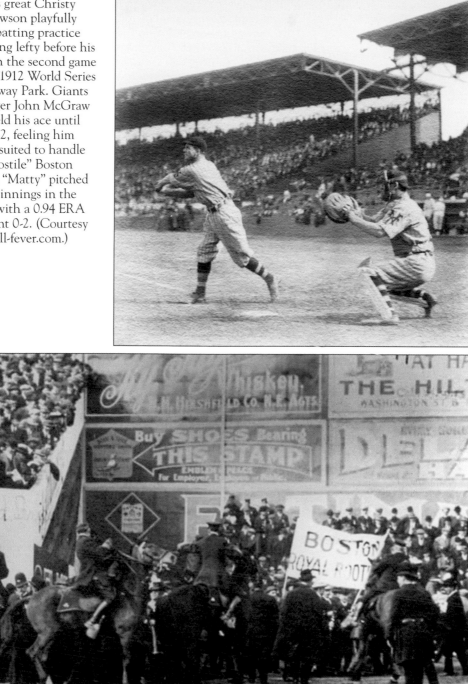

A near riot ensued when the Royal Rooters showed up and their customary Fenway Park seats on "Duffy's Cliff" had been sold. The mounted police were called in to restore order. The Giants won 11-4, evening up the 1912 series at three games. In protest, the Rooters called for a boycott of the championship game, and the next day only 17,034 witnessed the Red Sox win their first World Series at Fenway Park.

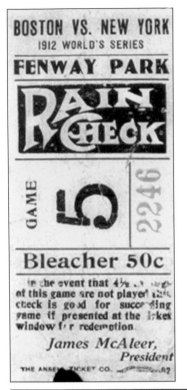

This ticket stub is from Game 5, in which the Red Sox 22-year-old rookie pitcher Hugh Bedient bested the great Christy Mathewson and New York 2-1. The win gave Boston a commanding 3-1 lead in the series. Bedient also hurled seven innings in the series' decisive game, surrendering only one unearned run before turning the game over to "Smokey" Joe Wood. (Courtesy of author's collection.)

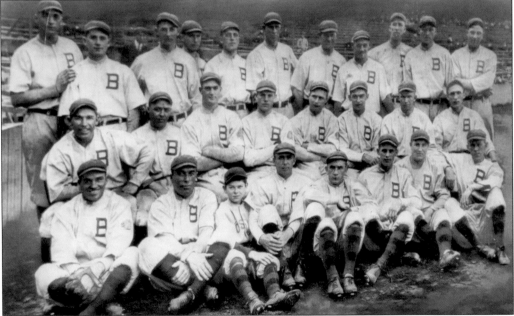

The Boston Braves often used Fenway Park as their home between 1913 and 1915—their antiquated home park, the South End Grounds, was falling into disrepair. They earned the nickname "Miracle Braves" in 1914 when, after floundering in last place in mid-July, they rallied to overtake the New York Giants for the pennant. Ticket scalpers sold $1 seats for $5 to a Fenway doubleheader between the two teams late that season.

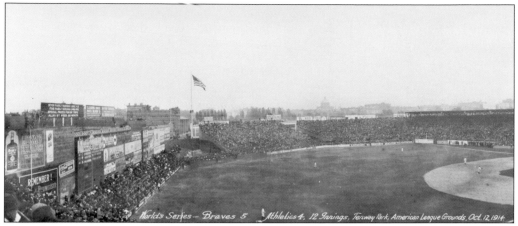

The Fenway magic continued for the Braves as they went on to sweep the heavily favored Philadelphia Athletics in the World Series. Depicted here is the Fenway crowd at the Braves' first World Series game in Boston on October 12, 1914. With Hall of Famers "Rabbit" Maranville and Johnny Evers, Boston won this game 5-4 and clinched the series the following day.

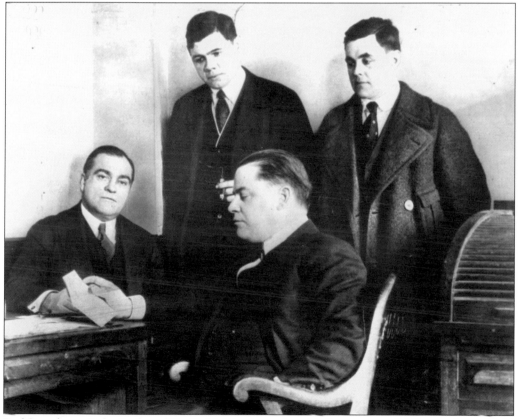

Red Sox players Babe Ruth and Stuffy McGinnis confer with Sox manager Ed Barrow (seated left) and owner Harry Frazee (seated right) as they prepare for the 1918 World Series. Due to World War I, the 1918 season was cut short and the series was played in early September. Games 4, 5, and 6 were played at Fenway Park, and their Game 6 win gave them their last world championship until 2004. (Courtesy of the *Sporting News*.)

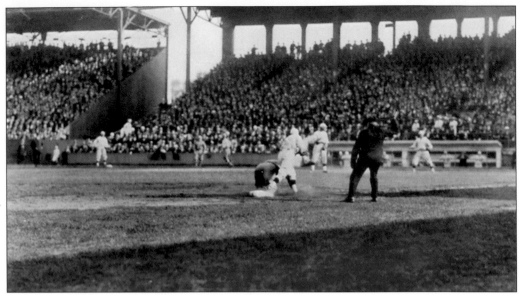

The Fenway Park crowd cheers as umpire Bill Klem calls out Cubs first baseman Fred Merkle, forced out at third base on a failed sacrifice bunt attempt by Chuck Wortman. Joe Bush (center of diamond) had just replaced Babe Ruth, who was sent to left field. Red Sox first baseman "Stuffy" McInnis fired to Fred Thomas getting lead runner Merkle at third. Second baseman Dave Shean is covering first base.

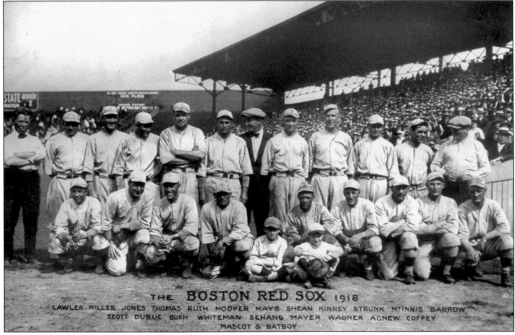

The 1918 World Champions became legendary as decade after decade passed without the Red Sox winning another World Series. This Sox team brought Boston their fifth world championship in the first 18 seasons of the American League but marked the end of the Red Sox dynasty, which dominated baseball from 1903 to 1918. It would be 86 long years before they would win another World Series.

The 1946 All-Star game at Fenway Park became Ted Williams's personal playground as he went 4-4 with five RBIs and hit two home runs, leading the American League to a 12-0 win. One homer came off Pittsburgh Pirates pitcher "Rip" Sewall's famous Eephus pitch, which was a ball lobbed slowly on a high arc with the intent of tantalizing a batter to overswing. (Courtesy of fenwaypark100.org.)

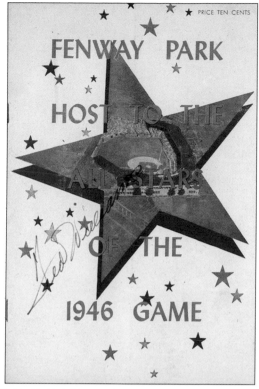

★ PRICE TEN CENTS

FENWAY PARK

HOST TO THE

ALL STARS

OF THE

1946 GAME

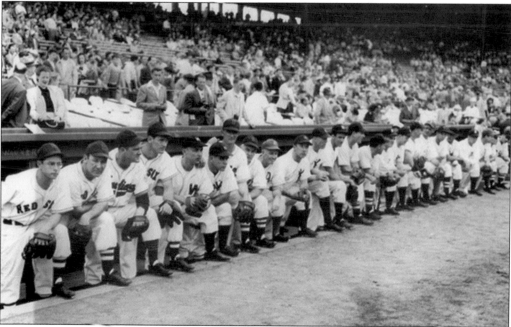

Established in 1933, the all-star game would not come to Fenway Park until 1946. The Red Sox placed six players on the American League squad; three are visible in this photograph. At far left is Dominic DiMaggio with Rudy York standing next to him, and Ted Williams is fourth from left. Bobby Doerr, Johnny Pesky, and Hal Wagner also made the team.

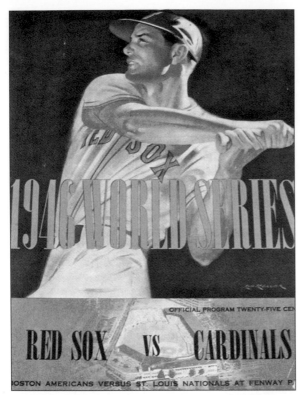

After the Red Sox clinched the 1918 World Series at Fenway Park on September 11, 1918, it was 9,890 days before the park hosted another World Series game. The Red Sox were favored to win the World Series, however, lost in seven games when Cardinals outfielder Enos "Country" Slaughter scored the deciding run in Game 7 with a mad dash from first base on an eighth-inning single. (Courtesy of fenwaypark100.org.)

The 1946 Red Sox won the pennant by 12 games and set a record of 15 consecutive wins; a record that still stands. Fenway Park was buzzing with anticipation of its first World Series in 22 years. In this photograph, from left to right, shortstop Johnny Pesky, second baseman Bobby Doerr, third baseman Mike Higgins, backup Rip Russell, and first baseman Rudy York await the start of Game 3 of the 1946 World Series.

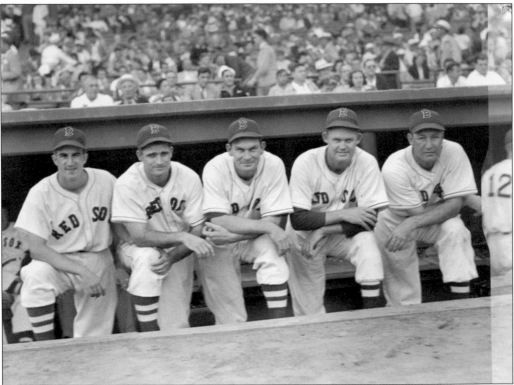

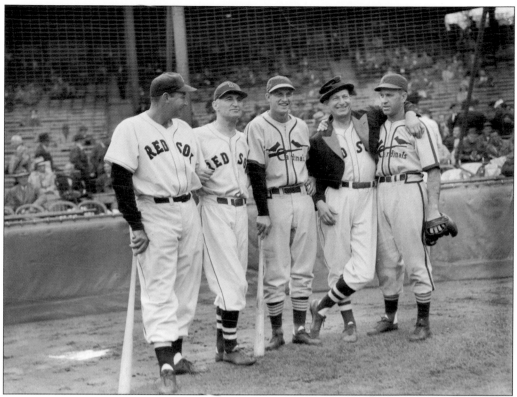

Red Sox and Cardinals players joke with the "Clown Prince of Baseball," Al Schacht, before Game 3 of the 1946 World Series on October 9. Shown here are, from left to right, first baseman Rudy York; an unidentified player; Stan Musial; Schacht, in Red Sox uniform, top hat, and tails; and Enos Slaughter. Dave Ferriss's six-hit shutout this day gave Boston a two-games-to-one series lead.

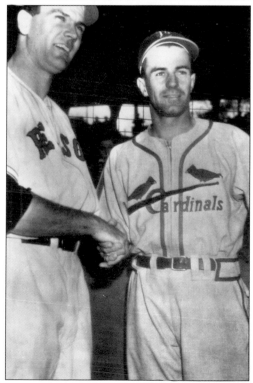

The Red Sox starting pitcher, Dave "Boo" Ferris, shakes hands with his Cardinals counterpart Murray Dickson before they square off for Game 3 of the 1946 World Series at Fenway Park. Ferris was the ace of the Red Sox staff in 1946 going 25-6, while Dickson was 15-6 for St. Louis, mostly out of the bullpen.

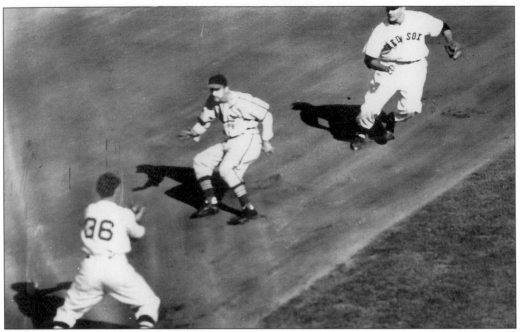

Cardinals star Stan Musial is caught between Red Sox pitcher "Boo" Ferris and third baseman Mike Higgins (No. 36). Musial walked in the first inning of Game 3 of the 1946 World Series and stole second but was quickly picked off by Ferris and was tagged out by Higgins. Musial had only six hits in the series, but five were for extra bases and he drove in four runs.

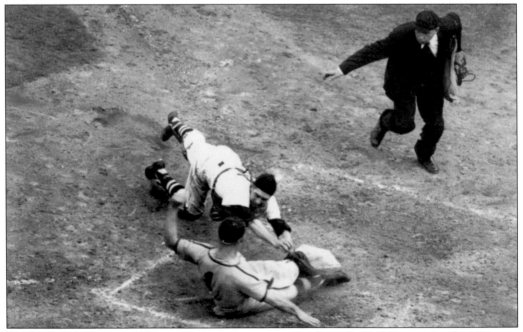

Cardinals third baseman Whitey Kurowski is tagged out at home by Red Sox catcher Hal Wagner in Game 4 of the 1946 World Series. The Cardinals, however, prevailed, winning the game 12-3 and evening up the series. The Red Sox won the next day at Fenway but lost Games 6 and 7 at Sportsman's Park, beginning a streak where they lost four consecutive World Series in seven games.

In 1948, Fenway Park was the scene of the first ever one-game playoff for the American League pennant, which involved the Red Sox and the Indians. Cleveland sent rookie Gene Bearden, who had pitched a complete game just two days before, while the Red Sox opted for Denny Galehouse, despite having ace Mel Parnell available. Here, Bearden is carried off the field by his mates after winning the game 8-3.

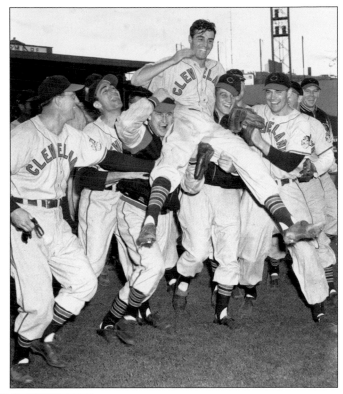

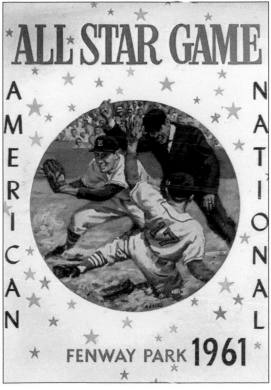

Fenway Park hosted its second all-star game on July 31, 1961. In 1959, 1960, 1961, and 1962, there were two all-star games played each year, one in an American League city and one in a National League city. Fenway was the second game played in 1961, and the first one to end in a tie as rain put an end to a 1-1 contest. (Courtesy of fenwaypark100.org.)

73

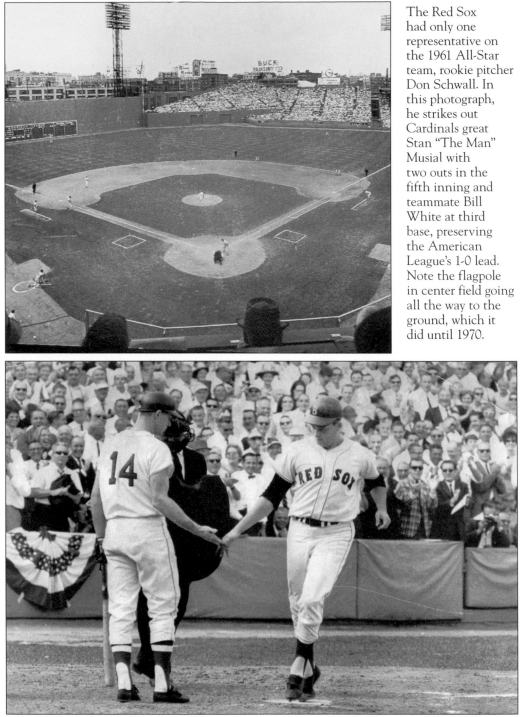

The Red Sox had only one representative on the 1961 All-Star team, rookie pitcher Don Schwall. In this photograph, he strikes out Cardinals great Stan "The Man" Musial with two outs in the fifth inning and teammate Bill White at third base, preserving the American League's 1-0 lead. Note the flagpole in center field going all the way to the ground, which it did until 1970.

Jerry Adair greets Red Sox pitcher Jose Santiago as he crosses home plate following his third-inning home run in Game 1 of the 1967 World Series. Santiago was the first native of Puerto Rico to start a World Series game, and he came up short, losing to Bob Gibson and the Cardinals 2-1. He was the first pitcher to homer in his first World Series at bat.

Fenway Park saw history when Jim Lonborg pitched a one-hitter, leading the Red Sox to a 5-0 win in Game 2 of the 1967 World Series. Lonborg lost his no-hitter with two outs in the eighth inning when Julian Javier doubled off the left-field wall. He was the fourth pitcher to hurl a complete game one-hitter in World Series competition. It has not been done since.

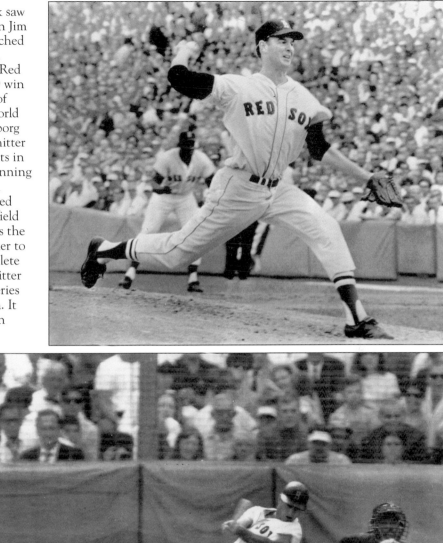

Carl Yastrzemski provided the offensive punch in Game 2, hitting two homers and driving in four of the Red Sox's runs. Here, he deposits a Dick Hughes pitch into Fenway's right-field grandstands, giving Boston a 1-0 lead. He hit a three-run homer in the seventh. The catcher is Tim McCarver, and the umpire is Al Barlick. Yaz continued his miraculous 1967 season in the World Series, hitting .400 with three home runs and five RBIs.

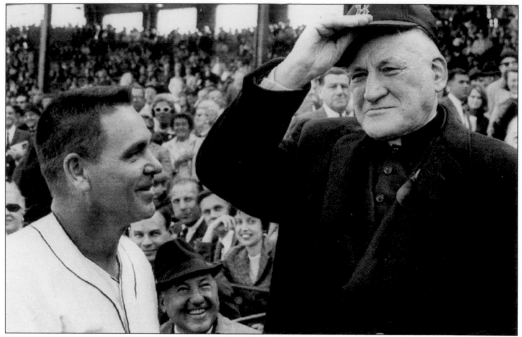

The 1967 World Series returned to Fenway Park on October 11. The Red Sox were down 3-2 and facing elimination when manager Dick Williams conferred with Cardinal Cushing before the game, perhaps seeking divine intervention. It worked as Rico Petrocelli hit two home runs and Yaz and Reggie Smith added one each, leading the Red Sox to an 8-4 win and setting up Game 7 the following day.

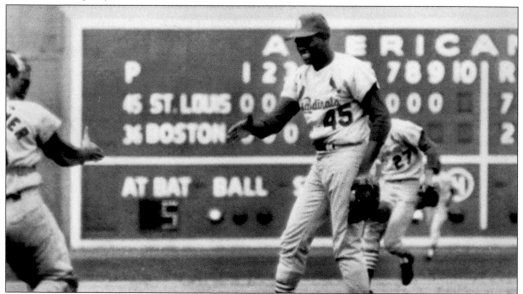

Game 7 pitted Jim Lonborg, on two days rest, against Bob Gibson. The Fenway scoreboard reveals that the day belonged to Gibson and the Cardinals, who prevailed. Gibson extends his hand to catcher Tim McCarver as Dal Maxvill (No. 27) prepares to join the celebration. Gibson, who struck out 10, had three complete game victories and a 1.00 ERA, earning him the 1967 World Series MVP Award.

The 1975 World Series is among the most historic ever played, and its greatness can be encapsulated in what has come to be known simply as "Game 6" played at Fenway Park. In what the MLB Network has called the greatest game ever played, the Red Sox prevailed 7-6 in 12 innings to tie the series at three games apiece. (Courtesy of fenwaypark100.org.)

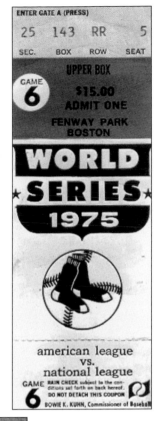

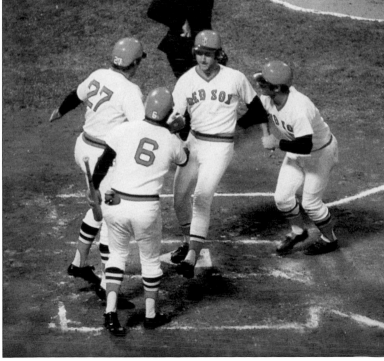

Fred Lynn is greeted at home plate following a three-run homer in the first inning of Game 6 of the 1975 World Series. He is greeted by Carl Yastrzemski; Carlton Fisk (No. 27), who scored ahead of him; and on deck hitter Rico Petrocelli (No. 6). The rookie center fielder hit .280 with a home run and five RBIs in the series. (Courtesy of fenwaypark100.org.)

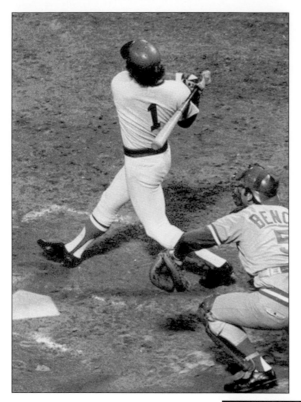

In the bottom of the eighth inning of Game 6, the Red Sox trailed 6-3 and were four outs away from elimination. Bernie Carbo was called upon to pinch hit and delivered a three-run homer into Fenway's center-field bleachers, tying the score and sending the game into extra innings and the Fenway Faithful into delirium.

Game 6 went into extra innings, and in the bottom of the 12th, Carlton Fisk (pictured) stood with Fred Lynn preparing to lead off the inning. He said to Lynn, "I've got a feeling something good's going to happen, I'll hit the wall and you drive me in." Fisk did not hit the wall—instead he hit the foul pole in left field for a home run, tying the series.

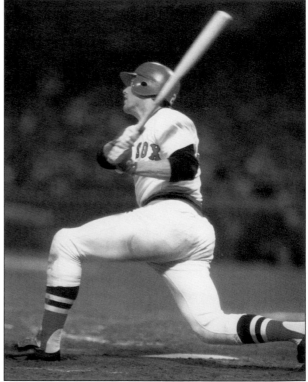

The Red Sox held a 3-0 lead and were 10 outs away from winning the World Series when Cincinnati Reds first baseman Tony Perez launched a Bill Lee slow curve over the left-field screen, making the score 3-2. The Reds scored a run in the seventh and another in the ninth, taking the series four games to three.

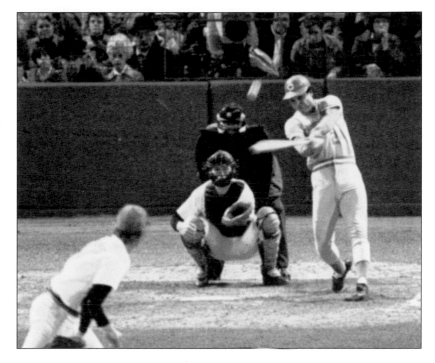

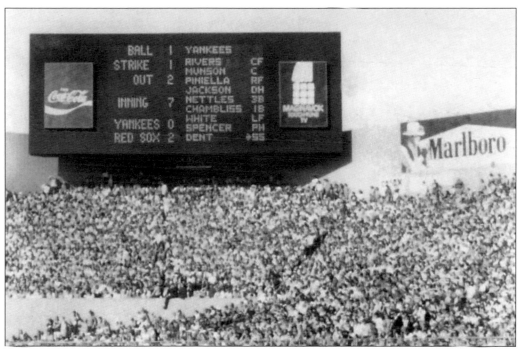

In 1978, another one-game playoff was held at Fenway Park, this time to decide the American League East Champion. In the seventh inning, Yankee shortstop Bucky Dent fouled a ball off his foot. As he was being tended to, the Fenway Park center-field scoreboard tells the tale. When play resumed, Dent hit a three-run homer, now legendary, into the net, propelling the Yankees to a 5-4 victory. (Courtesy of L.J. Sempre.)

Bruce Hurst strikes out Lenny Dykstra with Kevin Mitchell at third base. Hurst beat the Mets 4-2, giving the Red Sox a three games to two lead in the 1986 World Series. The Red Sox lost Games 6 and 7 in New York. Hurst was actually named the series MVP before the Red Sox collapsed. It was the events of this World Series that gave birth to "the Curse." (Courtesy of Adam Soloman.)

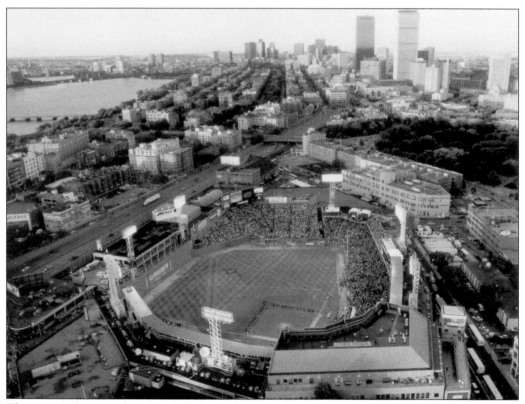

This aerial photograph, taken from high above Yawkey Way during the all-star game festivities of 1999, provides a unique and interesting perspective. The all-star game experience had grown significantly since its last appearance at Fenway in 1961, evolving into a three-day festival that included a celebrity softball game, a home run derby, and fan-friendly events. The number nine was cut into the grass in center field, honoring Ted Williams. (Courtesy Harrison Carew.)

The magic of baseball, the allure of Fenway, and the aura of heroes were all unveiled in one scintillating moment before the all-star game at Fenway Park on July 13, 1999. Ted Williams was enveloped by stars from both teams—each one reduced to the little boy who just wanted to get close to a genuine American hero. Assisted by Tony Gwynn, he threw out the first pitch, providing Fenway with an unforgettable moment. (Courtesy of Richard Santo.)

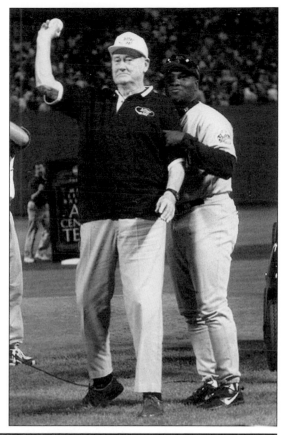

The night belonged to Ted Williams, but the game belonged to Pedro Martinez. Starting for the American League, he struck out five of the six batters he faced and went on to become the first pitcher in American League All-Star history to start and win a game in his home park. He was voted the game's MVP. (Courtesy of Jim Dexter.)

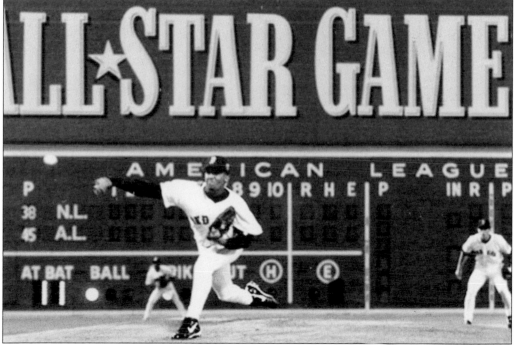

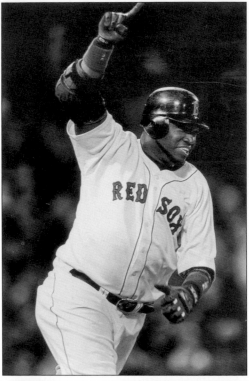

Red Sox designated hitter David Ortiz had Fenway Park frenetic for Games 4 and 5 of the 2004 American League Championship Series. Winning Game 4 with a two-run homer in the 12th inning, he continued the Red Sox comeback the following night with an eighth-inning homer and won that game with an RBI single in the 14th inning. For the series, he hit .387 with three homers and 11 RBIs. (Courtesy of Barton Silverman.)

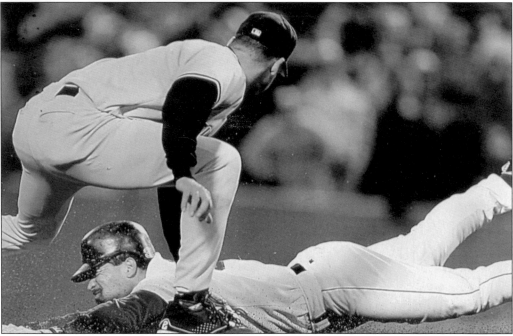

By 2004, it had been 18 years since the last World Series at Fenway Park. The Red Sox's appearance in the series that year would require the greatest comeback in baseball history. Down three games to none to the dreaded Yankees, the Red Sox rallied to sweep the next four games. Here, Dave Roberts's stolen base in Game 4 sparked the historic comeback. (Courtesy of Stan Lipsett.)

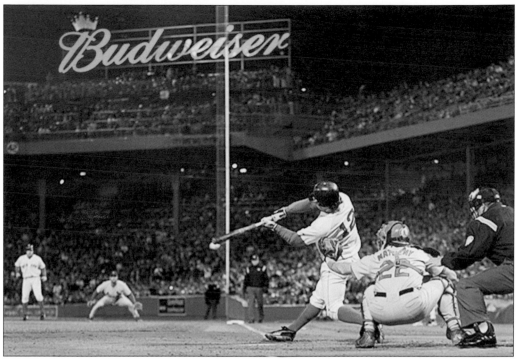

The World Series returned to Fenway Park on October 23, 2004, for the first time since 1986. Here, Mark Bellhorn connects for a two-run home run in the eighth inning off Cardinals pitcher Julian Tavarez. Bellhorn's blast provided the difference in the 11-9 Game 1 win. Bellhorn had two RBIs in Game 2's 6-2 victory. (Courtesy of J. Sayin.)

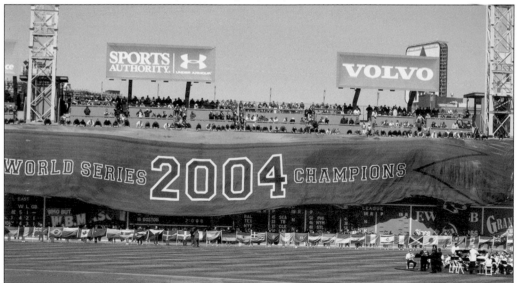

The Red Sox took Games 3 and 4 in St. Louis, beating the Cardinals 4-1 and 3-0. The sweep of the series brought a world championship to Fenway Park for the first time in 86 years. Here, Red Sox Nation celebrates as the 2004 championship banner is unfurled, adorning the Green Monster on opening day in 2005. It put an end to "the Curse" once and for all. (Courtesy of Monica Brady-Myerov for 90.9 WBUR, Boston's NPR News Station.)

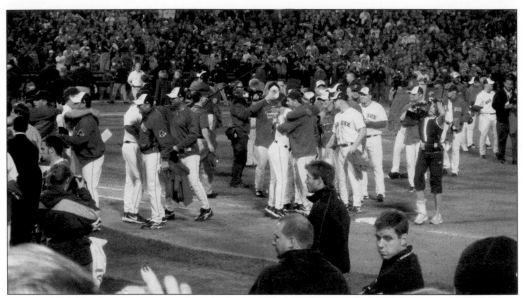

It is undeniable that Fenway Park and the Red Sox have enjoyed a renaissance of late. When Fenway opened, the Red Sox were the class of the league. After eight decades of futility, it all changed when in 2004, down three games to none to the Yankees in the American League Championship Series, they became the first team in baseball history to overcome such a deficit and win. They went on to sweep the Cardinals and end an 86-year championship drought. In 2007, they celebrated again (above), becoming World Champions for the second time in four years. Despite the difficulties and upheaval of 2011, there is no doubt that as Fenway Park's first century came to a close, it did so experiencing much of the glory it saw in its early years. Below, the 2004 and 2007 World Series trophies are on display. (Above, courtesy of Jonathan Pape; below, courtesy of S.J. Jackson.)

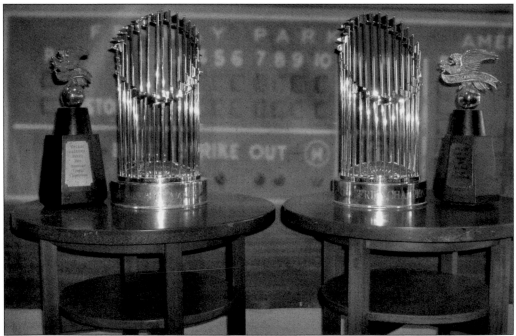

Four

THEY CALLED

FENWAY HOME

In its 100-year existence, 10 teams have called Fenway Park home. Yet it is the home of the Boston Red Sox that has defined Fenway in the hearts and minds of New Englanders.

When Fenway Park opened in 1912, Tris Speaker was emerging as one of the biggest stars in the game. He was gone by opening day of 1916, but Babe Ruth was on the verge of establishing himself as baseball's brightest star, first as its best left-handed pitcher and then as the unparalleled home run king. Babe joined established stars Duffy Lewis and Harry Hooper in a lineup that won three World Series in four years.

Throughout the past century, the roll call of Red Sox players has each provided a patchwork on the quilt of baseball, Fenway's history, and its folklore. Generations of players have taken their place of honor in the National Baseball Hall of Fame in Cooperstown, from Speaker and Hooper to Ruth; from Grove, Cronin, and Foxx to Doerr and Williams, who passed the baton to Carl Yastrzemski; and on to Carlton Fisk and Jim Rice. The next generation awaits history's judgment and includes Roger Clemens, Manny Ramirez, and Pedro Martinez.

Many more have contributed to Fenway's rich history in a myriad of ways, from capturing lightning in a bottle for a year, or a game, or a moment to tragically being cut down by injury or illness. Some became known for less than stellar performances or their unique personalities, and there were even those who went from goats to legends, transformed by time and circumstance.

The Royal Rooters, the Fenway Faithful, and Red Sox Nation have all established a special relationship with Fenway Park. That relationship has been developed and cultivated by the players who have called Fenway home, and each generation of Red Sox players are but stewards of that relationship—charged with the responsibility to preserve and enhance it and to pass it on.

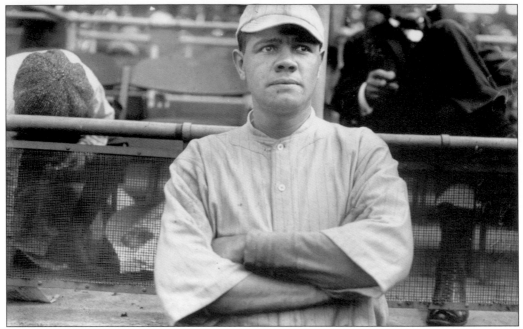

A 21-year-old Babe Ruth, in his third season with Boston, leans against Fenway's grandstand in 1916. At this juncture, Ruth was still strictly a left-handed pitcher, not having switched to the outfield yet. Young Babe was becoming a Fenway favorite and helped lead the Red Sox to world championships in 1915, 1916, and 1918.

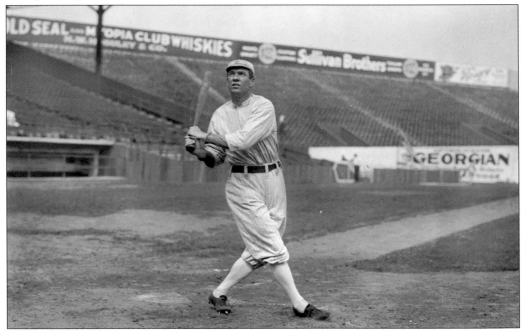

Tris Speaker played with the Red Sox from 1907 through 1915, and when Fenway opened in 1912, he was one of the league's brightest stars. The best player on the 1912 and 1915 championship teams, his 222 hits in 1912 were a team record for 73 years. His .345 career batting average ranks him sixth all time. He was elected to the National Baseball Hall of Fame in 1937.

Earning his nickname when *Boston Post* sportswriter Paul Shannon wrote, "That boy throws smoke," "Smokey" Joe Wood was 117-56 in seven seasons with the Red Sox. The ace of the staff, he was a lynchpin on Fenway Park's first championship team in 1912 and again in 1915. Walter Johnson said he threw harder than anyone he had ever seen. He is enshrined in the Red Sox Hall of Fame.

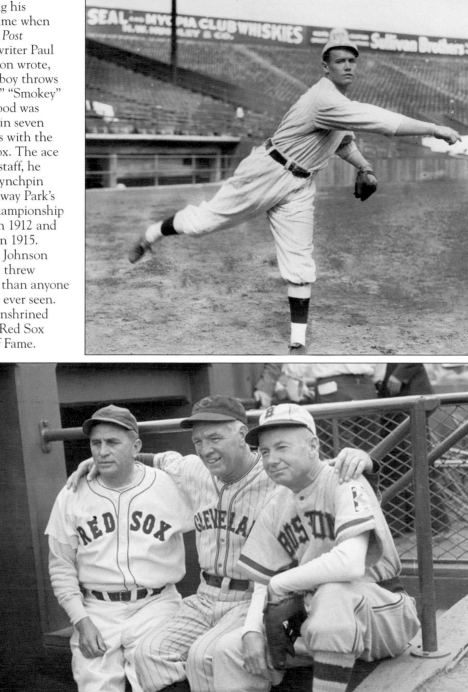

Harry Hooper, Tris Speaker, and Duffy Lewis are reunited at an Old Timers' Day at Fenway Park in 1939. The trio comprised the Red Sox outfield for Fenway Park's first four years of existence. They were part of 66 former players who turned out for this event. All three are in the Red Sox Hall of Fame; Hooper and Speaker are enshrined in Cooperstown as well.

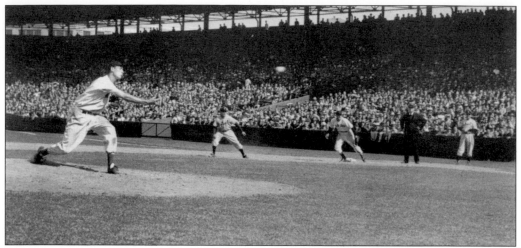

The greatest hitter who ever lived, on the mound? He did it only once, on August 24, 1940, at Fenway Park. With Detroit pummeling the Red Sox 11-1, "Teddy Ballgame" pitched the final two innings of the contest. He faced nine batters and surrendered one run on three hits. He did not walk a batter and even had one strikeout. The Red Sox lost 12-1.

Johnny Pesky met Ted Williams when Pesky was a clubhouse boy with the Portland Beavers of the Pacific Coast League. He laundered the visiting team uniforms when Ted was playing with San Diego. Pesky joined Williams with the Red Sox in 1942, and the following year they were studying together to become naval aviators. Here, they visit the Red Sox dugout in April 1943, watching the Red Sox beat the Yankees 5-1.

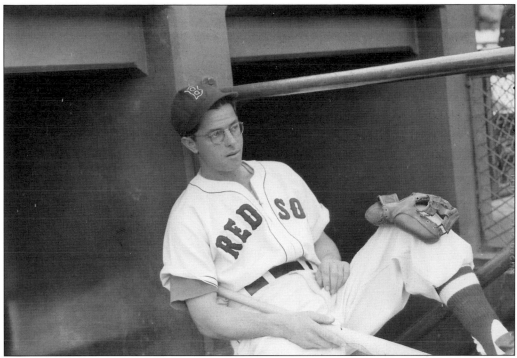

Dom DiMaggio, the younger brother of Joe, intently awaits Game 3 of the 1946 World Series. "The Little Professor" called Fenway Park home for 11 seasons. A seven-time all-star, the fleet-footed, slick-fielding center fielder was a constant base-stealing threat. While with the Red Sox, he forged a friendship with Bobby Doerr, Johnny Pesky, and Ted Williams that is now forged in bronze on Van Ness Street outside Fenway Park.

Mel Parnell called Fenway home from 1947 to 1956 and is recognized as one of the greatest southpaws in Red Sox history. Twice a 20 game winner, he compiled a record of 123-75 and in 1956 pitched a no-hitter at Fenway Park against Chicago. In this photograph, he has a little Fenway fun after the Red Sox opener was snowed out in 1953.

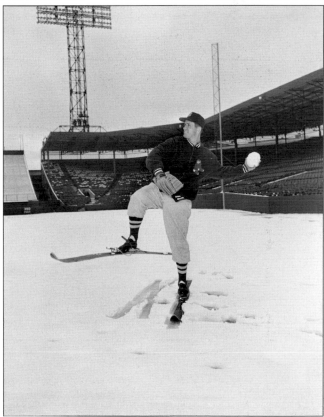

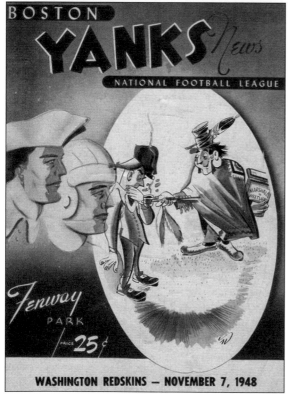

Originally the Boston Braves, they moved to Fenway Park in 1933 and changed their name to the Redskins. They called Fenway home from 1933 to 1936 before moving to the nation's capital. Here, they are shown in action against the New York Giants on October 8, 1933, on their way to a 21-10 win.

A short-lived NFL team called the Boston Yanks called Fenway home from 1944 to 1948. This program is from a game with the Washington Redskins on November 7, 1948, which they lost 23-7. In 1944, they drafted Heisman Trophy winner Angelo Bertelli, the Notre Dame quarterback, though he never played for them. The Yanks folded following the 1948 season but not before upsetting the Eagles 37-14 at Fenway in their last game ever played. (Courtesy of fenwaypark100.org.)

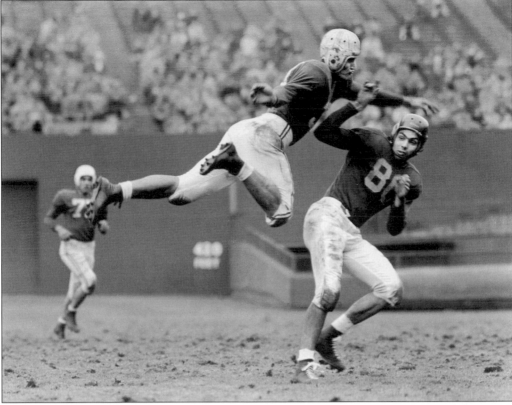

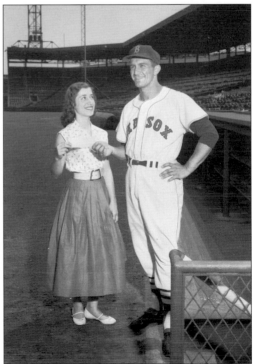

Harry Agganis, a three-sport standout at Lynn Classical High School, was recruited by 75 colleges. Choosing Boston University, he excelled in both baseball and football. "The Golden Greek" became an All-American quarterback and played defense as well. He left BU holding records in passing yardage, touchdown passes, punting average, and interceptions. A first-round draft pick of the Cleveland Browns, he opted to call Fenway home and signed with the Red Sox, cracking their lineup in 1954. He died tragically in June 1955 from a pulmonary embolism. In the above photograph, he deflects a pass while playing defensive back at Fenway Park in 1951. In the photograph at right, he presents a scholarship check to Cleo Sophias just one month before his death. Today, the nationally acclaimed BU hockey team calls the Harry Agganis Arena home. (Both, courtesy of BU Photography.)

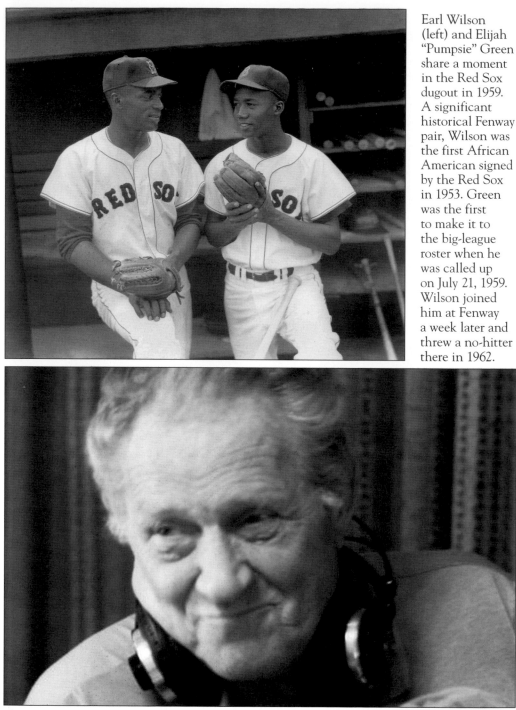

Earl Wilson (left) and Elijah "Pumpsie" Green share a moment in the Red Sox dugout in 1959. A significant historical Fenway pair, Wilson was the first African American signed by the Red Sox in 1953. Green was the first to make it to the big-league roster when he was called up on July 21, 1959. Wilson joined him at Fenway a week later and threw a no-hitter there in 1962.

Sherm Feller was as much a Fenway Park institution as any player, manager, or coach. He was the public address voice of Fenway Park from 1967 to 1992. A true renaissance man, he was an accomplished songwriter and musician as well. He participated in the 100th anniversary concert of the Boston Pops and wrote the hit song *Summertime, Summertime*. He passed away in 1994; however, his voice still lives on. (Courtesy of shermfeller.com.)

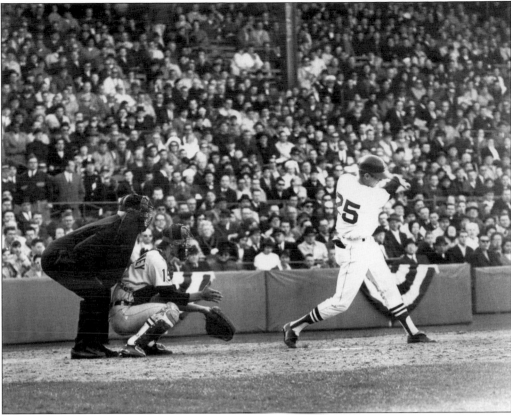

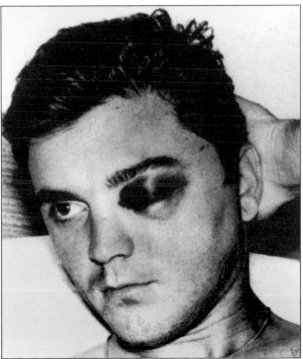

Destined for greatness, local hero Tony Conigliaro was 19 years old when he homered in his first Fenway at bat in April 1964. In three short years, he became the youngest American League home run champ, the youngest American League player to reach 100 home runs, and an all-star. But fate would deal him a cruel blow. It was August 1967 and a pitch hit him on the side of the face, damaging his eyesight. He missed the entire 1968 season, and it appeared his vision was permanently impaired, so he attempted to become a pitcher. Almost miraculously, his sight returned, and he was in the lineup on opening day in 1969. That year he won the Comeback Player of the Year Award. Following his death in 1990, the Red Sox founded the Tony Conigliaro Award to honor his memory. (Both, courtesy of author's collection.)

The BOSTON PATRIOTS — Champions Eastern Division 1963
FOOTBALL CLUB

FENWAY PARK
BOSTON, MASS. 02215
COngress 2-1776

WILLIAM H. SULLIVAN JR.
President

MICHAEL J. HOLOVAK
General Manager and Head Coach

TO THE GREATEST FANS IN THE WORLD:

This year the National Football League, in general, and the
Baltimore Colts and the Washington Redskins, in particular, are
learning what the American Football League teams have long known,
the Patriots are supported by the finest fans in the world.

Your major contribution to our progress will not be forgotten
by the directors, coaches, players, and the office staff of our
club.

In saluting you for your loyalty and thanking you for your
enthusiastic support, may I promise you that we will devote our
continuing efforts to provide a championship team because you are
worthy of just exactly that.

Sincerely,

Bill Sullivan

William H. Sullivan, Jr.

WHS/jh

BUFFALO BILLS ● HOUSTON OILERS
MIAMI DOLPHINS ● NEW YORK JETS
● BOSTON PATRIOTS ●
DENVER BRONCOS ● KANSAS CITY CHIEFS
SAN DIEGO CHARGERS ● OAKLAND RAIDERS

Billy Sullivan bought the Boston Patriots franchise for $25,000. A former employee of the Boston Braves, Sullivan saw potential in the newly formed American Football League. He established Fenway Park as the home of his Patriots from 1963 to 1968. On a letterhead proclaiming just that, he thanks the fans for their support and pledges to continue to bring them the caliber of football they deserve. In the photograph below, Boston Patriots quarterback Vito "Babe" Parilli, one of the AFL's first stars, fires a pass downfield against the Chargers before an empty left-field grandstand. They departed Fenway following the 1968 season in favor of Harvard Stadium and Alumni Field before finally landing in Foxboro, Massachusetts. (Both, courtesy of author's collection.)

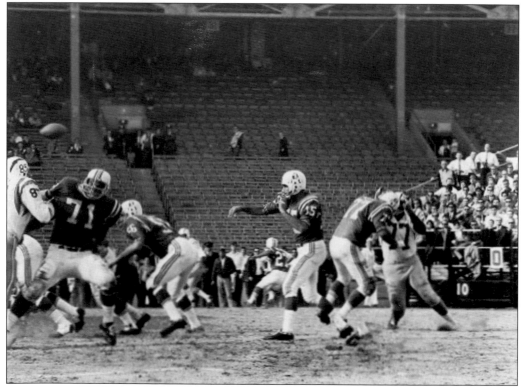

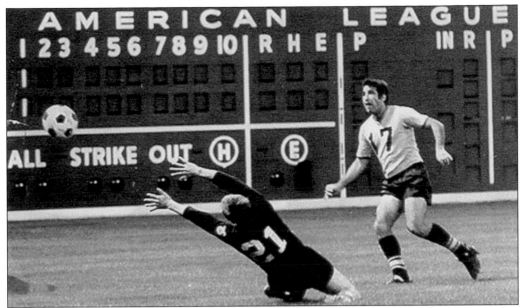

The Boston Beacons of the North American Soccer League played their home games at Fenway in 1968. The team was a refined version of the Boston Rovers, who played in the US Soccer Association in 1967 and played their home games in Lynn. The Beacons lasted only one year; though a highlight was hosting the incomparable Pelé and his touring Brazilian team for an exhibition game that August.

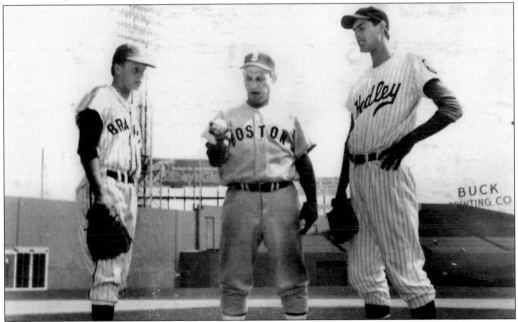

Red Sox legend Frank Malzone stands between pitchers Dick Blackwell (left) and Tom White (right), who were the starters in the sandlot championship game in August 1969. Fenway was a site for the William Randolph Hearst Sandlot Championships from 1952 through 1971. The first game was played on July 29, 1947, and then resumed in 1952. Malzone, a six-time all-star, was the director of the Fenway tournament.

A native New Englander, Carlton Fisk played 10 seasons with the Red Sox. The Rookie of the Year in 1972, "Pudge" was a six-time all-star while in Boston. His best season came in 1977 when he hit .315 with 26 home runs and 102 RBIs. His hard-nosed play and exploits during the 1975 World Series left an indelible mark upon Fenway Park. He was inducted into Cooperstown in July 2000.

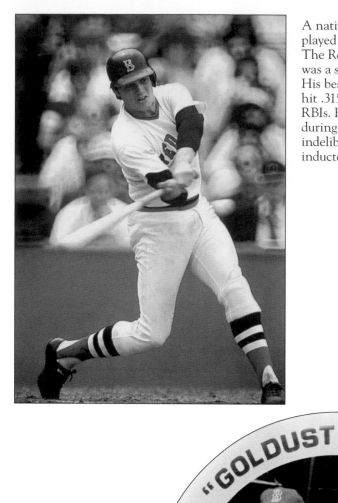

Fred Lynn and Jim Rice arrived at Fenway Park in September 1974. They took the league by storm, and in 1975 these two rookies led the Red Sox to the pennant. Lynn won the Rookie of the Year and MVP Awards, becoming the first player to do so. Rice was named the MVP in 1978 and was inducted into the National Baseball Hall of Fame in 2009. (Courtesy of fenwaypark100.org.)

Red Sox pitcher Luis Tiant watches his dad throw out the first pitch at Fenway Park in August 1975. The elder Tiant, an outstanding pitcher in Cuba, had just arrived the week before in Boston. Tiant had not seen his parents in 16 years when Sen. George McGovern interceded, gaining permission from Fidel Castro for the Tiants to make the trip to the United States.

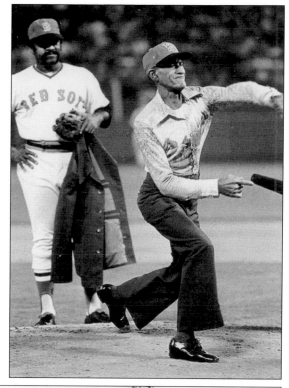

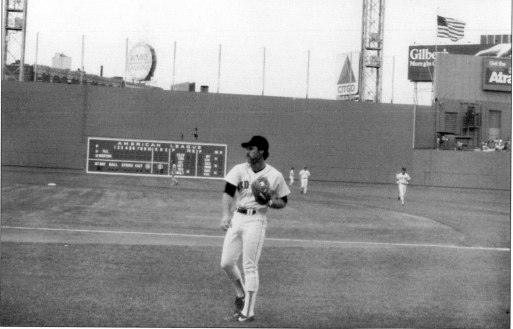

Red Sox third baseman Wade Boggs engages in the routine ritual of warming up on the sidelines before a game in August 1983. Boggs was in his first season as the team's regular third baseman and was embarking on a decade in which he was regarded as one of the finest hitters in baseball. He won five American League batting titles in the 1980s. (Courtesy of author's collection.)

Few events at Fenway Park have evoked more emotion than Yaz Weekend in October 1983. The Fenway Faithful displayed their love and gratitude for the "The Captain" as he played in his final two games, and he reciprocated in kind. Surrounded by his family, he acknowledges the crowd. The weekend was filled with multiple standing ovations and the first ever player's lap around the field shaking hands with fans. (Courtesy of 42367.)

Dwight Evans acknowledges the Fenway Faithful with a wave of his hand. The standard by which all Red Sox right fielders were measured, "Dewey" patrolled the Fenway outfield for 19 seasons. He was a three-time all-star, and he garnered eight Gold Glove Awards. A four-time winner of the Tom Yawkey Award for the Red Sox MVP, his 379 home runs ranks him fourth on the all-time Red Sox list.

Arriving in Boston in 1984 with as much potential as any Red Sox pitching prospect in history, "The Rocket" fulfilled his promise in 1986, going 24-4 and capturing the Cy Young and MVP Awards. Roger Clemens called Fenway home for 13 seasons, winning 192 games and twice striking out 20 batters in a game. Here, he acknowledges the Fenway crowd while being honored for his third Cy Young Award as general manager Dan Duquette applauds. (Courtesy of author's collection.)

Listed at five feet, nine inches, and 180 pounds, Dustin Pedroia plays like a giant at Fenway Park. He was the American League Rookie of the Year in 2007 and the MVP in 2008. He joined a very exclusive club by winning Rookie of the Year honors and a World Series ring during the same season. His all-out hustling style has made him a favorite of Red Sox Nation. (Courtesy of Birry Ree.)

Curt Schilling joined the Red Sox for the 2004 season, and he went 21-6, finishing second in the voting for the Cy Young Award. He eternally cemented his name in Fenway Park lore when he beat the Yankees in Game 6 of the American League Championship Series with a sutured ankle in what has become known as the "Bloody Sock" game. He was 6-1 in eight post-season Red Sox starts. (Courtesy of Linnea Johnson.)

In 1967, Jim Lonborg emerged as one of the premier pitchers in the league, going 22-9 and winning the Cy Young Award. A skiing injury sidetracked his career and he was traded in 1972, but he never left Boston. Establishing a dental practice on Boston's south shore upon retirement, Dr. Lonborg still calls Fenway home. Here, he enjoys the game with wife Rosemary, son Jordan, and Jordan's girlfriend Molly. (Courtesy of Jim Lonborg.)

Five

PLAQUES, HONORS, AND THE RED SOX HALL OF FAME

There is no greater honor the Red Sox can bestow upon any player than to have their number retired. As Fenway Park celebrates its 100th birthday, eight numbers watch over her from their place of honor on the right-field facade—1, 4, 6, 8, 9, 14, 27, and 42. Each player is recognized for their contributions made to the Red Sox and baseball, with 42 honored throughout baseball for Jackie Robinson's historical significance.

The seven retired Red Sox numbers represent the elite members of the Boston Red Sox Hall of Fame members. Each has a plaque honoring them inside the State Street Pavilion at Fenway Park. Also immortalized within the Red Sox Hall of Fame are eight memorable moments commemorating significant events in the history of the team. Photographs and memorabilia are displayed on the EMC Level of the ballpark in a chronology of Red Sox history.

A historical flavor has been added to the outside of the park as well with two bronze statues as the centerpieces. They showcase the Ted Williams *Jimmy Fund* statue (unveiled 2004) and the *Teammates* statue of Ted Williams, Dom DiMaggio, Bobby Doerr, and Johnny Pesky (2010).

Erected in 1934, this plaque commemorates the reconstruction of Fenway Park following its purchase by Tom Yawkey in 1933. It has been displayed outside the entrance to the business portion of Fenway Park and the Red Sox for eight of its 10 decades. In that time, it has seen the transformation of Jersey Street to Yawkey Way and then Yawkey Way transformed into part of the ballpark itself. Tom Yawkey's decision to refurbish Fenway without regard to cost during the Depression helped it become the park with which fans have fallen in love. The recently completed 10-year renovation under the current ownership has added to the foundation began by Yawkey. Their incorporation of the history and tradition of Fenway Park with the addition of modern amenities have enhanced the Fenway Park experience and played a significant role in the fact that the Red Sox entered the 2012 season having sold out every Fenway Park game since May 15, 2003, a total of 714 games. (Courtesy of Ruthann Sorella.)

As an owner, Tom Yawkey developed a reputation for taking very good care of his players. Some, throughout the years, have suggested that this, at times, hurt the team's performance on the field. That notwithstanding, there is no doubt that Yawkey was a great boss, and when the city officially changed the name of Jersey Street to Yawkey Way in 1977, his employees honored him. (Courtesy of Brady Dylan.)

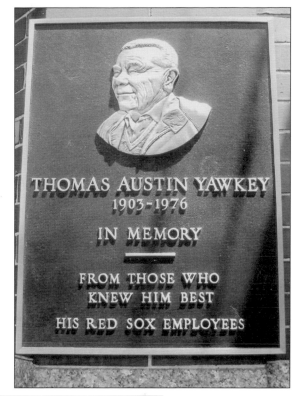

Van Ness Street runs from Yawkey Way down to the right-field entrance to Fenway Park. In the past decade, it has taken on the flavor of an outdoor museum with banners hanging and retired numbers displayed on the brick facade. Here hang banners honoring many of the greatest players in Red Sox history. (Courtesy of Paula Componeschi.)

103

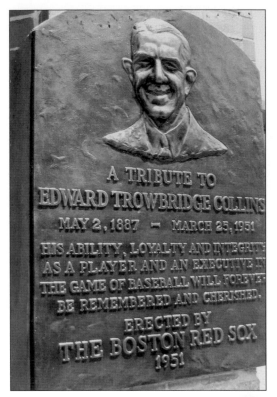

Eddie Collins was a Hall of Fame player from 1906 through 1930. He later became the general manager of the Red Sox in 1933, a position he held until succeeded by Joe Cronin 1947. His baseball acumen coupled with Yawkey's money rebuilt the Red Sox into contenders. He also discovered and signed both Ted Williams and Bobby Doerr. (Courtesy of Jake Taylor.)

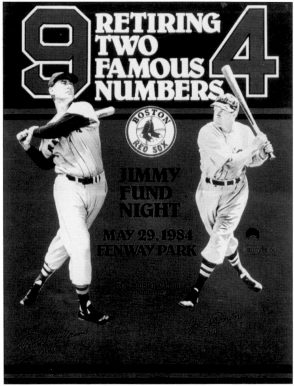

When Ted Williams retired following the 1960 season, the Red Sox announced that no other player would ever again wear the No. 9. There was no fanfare, no celebration, just an understanding and recognition that there would never ever be another Ted Williams. In May 1984, the Boston Red Sox officially retired the No. 9 along with Joe Cronin's No. 4 in a ceremony at Fenway Park. (Courtesy of KG6753.)

After the ceremony retiring both Ted Williams's and Joe Cronin's numbers, plaques were unveiled on the right-field facade and a new Fenway Park tradition was born. The Nos. 9 and 4 remained alone on the right-field facade until May 1988 when Bobby Doerr's No. 1 was added. (Courtesy of Steven Murphy.)

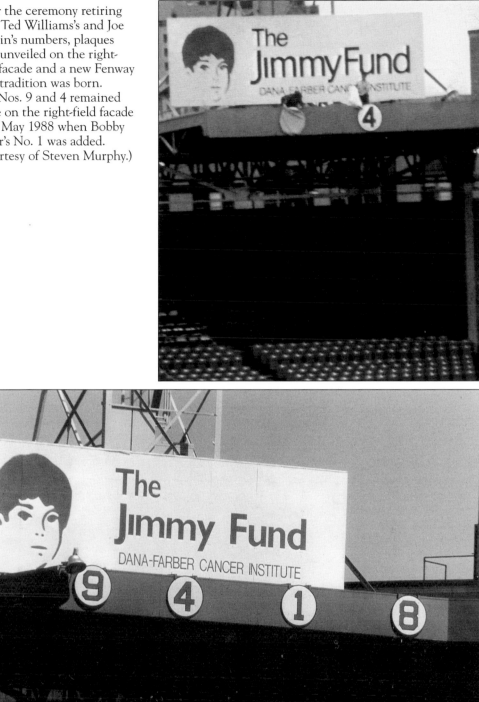

A year after Doerr's No. 1 was added and just days after Carl Yastrzemski's induction into the National Baseball Hall of Fame in Cooperstown, New York, Yaz's No. 8 joined the elite corps of Red Sox honorees. The retired numbers are positioned directly below the Jimmy Fund sign, which for decades was the only advertisement in the park. (Courtesy of Lyn Raymond.)

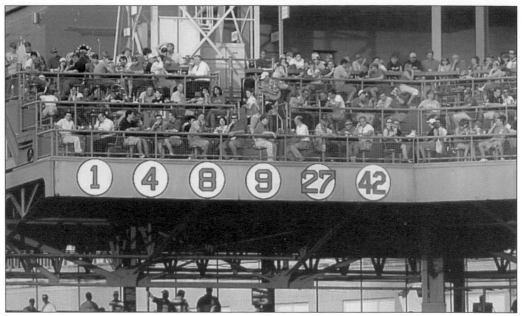

The facade bore the Nos. 9, 4, 1, and 8 from 1989 until 1997. On April 15 of that year, the 50th anniversary of Jackie Robinson breaking baseball's color barrier, Commissioner Bud Selig retired his No. 42 throughout baseball. The numbers on the facade were then switched to numerical order. In September 2000, fresh off his induction into Cooperstown, Carlton Fisk's No. 27 joined Fenway Park's place of honor. (Courtesy of Nancy Marie.)

On September 28, 2008, Johnny Pesky's No. 6 was unveiled. Pesky became the first Red Sox player not in the National Baseball Hall of Fame to have his number retired. After a lifetime of service with the team as a player, coach, manager, broadcaster, instructor, and goodwill ambassador spanning nearly seven decades, the organization bestowed the honor. Carlton Fisk, the previous honoree, unveils Pesky's number. (Courtesy of William Frank.)

Above, in July 2009, just two days after he was inducted into the National Baseball Hall of Fame, Jim Rice had his number join the lineup of Red Sox immortals. In the tradition started by Fisk unveiling Pesky's number, Rice's was thusly honored by Pesky. The custom that began three decades prior in a modest ceremony has become the greatest single honor that the Boston Red Sox can bestow upon an individual. These ceremonies have provided some of Fenway's most poignant moments. Below, Jim Rice's No. 14 watches over the Fenway Faithful as it awaits the next player to join him on Fenway Park's sacred facade. (Above, courtesy of Michael Naselroad; below, courtesy of Lynda Desaulniers.)

RED SEAT

On June 9, 1946, Ted Williams slugged a mammoth home run off Detroit pitcher Fred Hutchinson. Traveling deep into the right-field bleachers, the ball landed on top of the straw hat of Joseph A. Boucher, an Albany, New York native sitting in Section 42, Row 37, Seat 21. Officially measured at 502 feet, Williams' blast remains the longest-recorded home run in Red Sox history. Individual seats have since replaced the original, wooden bleacher benches that were part of the ballpark during the career of Williams and many other Sox legends. Today, amidst a sea of green bleacher seats, a single red seat is located in the spot where Boucher sat on that historic day.

Hanging on the wall on a ramp in the bleachers is a bronze plaque that tells the story of one of Ted Williams's most famous Fenway Park home runs. On June 9, 1946, against the Detroit Tigers, Williams hit a long fly that traveled deep into the right-field bleachers and was later measured at a distance of 502 feet from home plate. The titanic blast hit a snoozing fan on the head, breaking his straw hat. The seat he occupied, section 42, row 37, seat 21, was later painted red to commemorate the feat. Below is a photograph taken from the seat, looking in towards home plate. (Courtesy of Zachary Keene.)

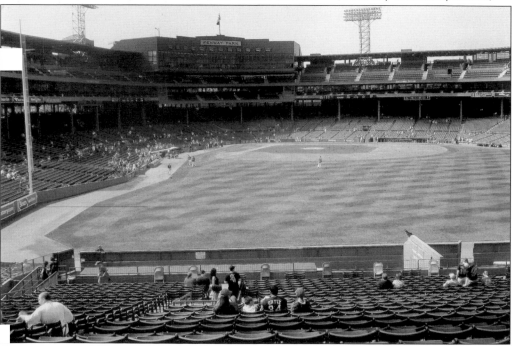

Another plaque on the wall of an outfield ramp is in honor of Carlton Fisk's dramatic home run in Game 6 of the 1975 World Series. Here is Fisk's view of that game-winning blast, which bounced off the left-field foul pole, forever giving it the nickname "Fisk's Pole." His stellar career culminated in his election to Cooperstown; however, Fisk will always be remembered for this moment. (Courtesy of Jerry Reuss.)

In 1995, the Red Sox established the Red Sox Hall of Fame. Its inaugural class featured such notable players as Babe Ruth, Ted Williams, Carl Yastrzemski, and Jim Rice. The Red Sox Hall of Fame included 77 members as of 2011 with elections being held every two years. It is housed on the first-base side of the State Street Pavilion at Fenway Park. (Courtesy of Remo Coradini.)

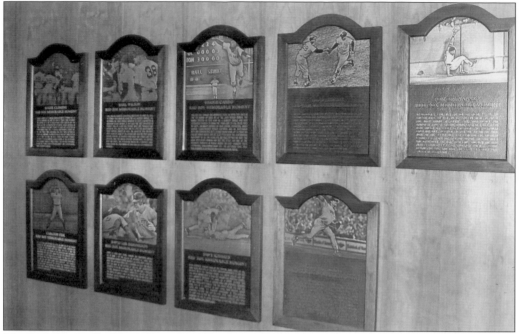

The Red Sox Hall of Fame has commemorated eight memorable moments in their history. Six of those moments have occurred at Fenway Park. They are, in order of occurrence: Ted Williams's home run in his last at-bat in September 1960; Earl Wilson's no-hitter in June 1962; Bernie Carbo's and Carton Fisk's home runs in Game 6 of the 1975 World Series; Roger Clemens's 20 strikeouts versus the Seattle Mariners in April 1986; and Dave Roberts's steal of second base in the ninth inning of Game 4 of the American League Championship Series versus the Yankees in 2004. Emblazoned in the collective memory of the Fenway Faithful, these great moments are forever enshrined at Fenway Park where their memories echo across the decades. (Above, courtesy of Reagan Kelly; below, courtesy of Margeaux Palavolo.)

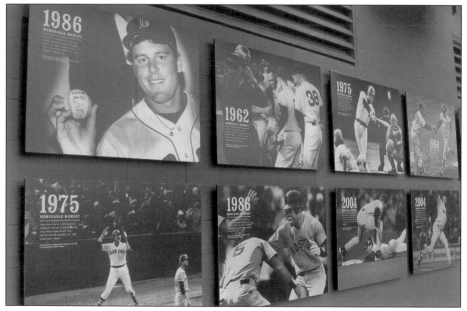

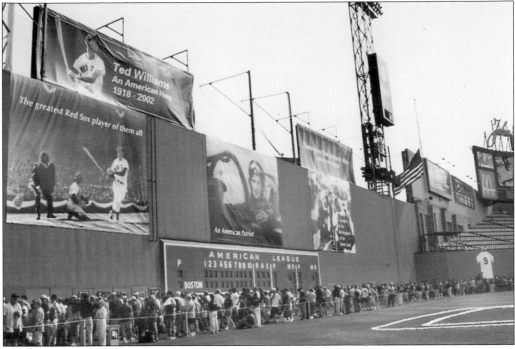

In July 2002, Red Sox legend Ted Williams passed away and Fenway Park took on yet another dimension. Above, fans gather in front of the left-field wall to pay their respects. Over 20,000 fans filed past the wall honoring the man who was a Marine fighter pilot, a member of the American Fishing Hall of Fame, and thought by many to be the greatest hitter who ever lived. The left-field wall is adorned with memories of "The Kid." His No. 9 can be seen hanging on the center-field wall. Below, in a poignant, somber moment, a Marine Honor Guard stands watch in tribute to a comrade gone before. On this day, Fenway Park was transformed into a shrine of tribute, honor, and remembrance. (Above, courtesy of Ben Saren; below, courtesy of Bill Nowlin.)

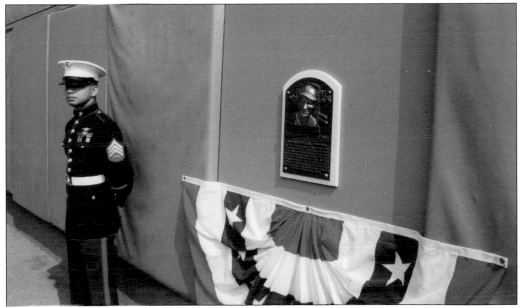

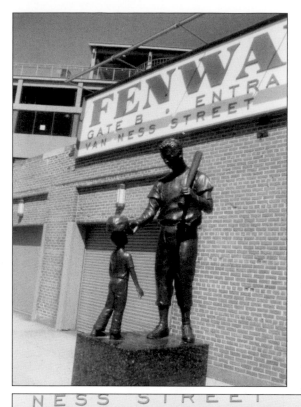

Sculptor Franc Talerico was touched by Ted Williams's devotion to the kids of the Jimmy Fund. With Ted's reputation for never tipping his cap, he thought it appropriate that he would give it to a kid (left) who was battling cancer and needed the Jimmy Fund. In an interview with Talerico's hometown newspaper, the *Venice Gondolier*, Ted's daughter Claudia said, "Franc has captured something in this statue that nobody else ever has. When I look into the eyes of that statue I see my dad." Below, the *Teammates* statue was born from a trip made by Johnny Pesky and Dom DiMaggio to Inverness, Florida, to visit an ailing Ted Williams. The friendship forged by these men transcended time and is now forever memorialized in bronze outside of the place they called home for so many years, Fenway Park. (Both, courtesy of Josh Palabase and Franc Talerico.)

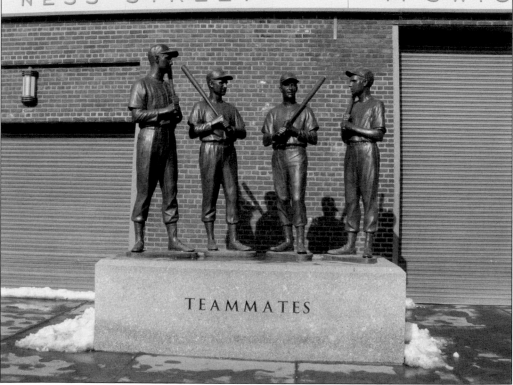

Six

NEW CENTURY,
NEW OWNERS, NEW IDEAS

In February 2002, a group led by John Henry, Tom Werner, and Larry Lucchino purchased the Red Sox, becoming the seventh owners in the history of Fenway Park. Immediately, they undertook a 10-year renovation program, which culminated in the winter of 2010. Under the initial direction of Janet Marie Smith (who oversaw the building of Baltimore's Camden Yards), Fenway Park was virtually reinvented both inside and out, converting it into a combination baseball venue, baseball festival, and Red Sox historical museum.

In 2003, seats were added atop the Green Monster. These "Monster" seats above the left-field wall instantly became among the best seat of any sports venue in the country. The project has added premium seating throughout Fenway's upper deck, replete with fine dining and luxury boxes and a complete renovation, improving seating, concessions, and sight lines throughout the ballpark. Outfitted now with state-of-the-art video boards in the outfield, the 100-year-old edifice is strengthened, well equipped, and ready for the next century.

As significant as all these changes may be, perhaps the most telling of all is that outside the ballpark has now become as much a part of the Fenway experience as the game itself. Yawkey Way is now part of the park, as it is closed off before game time and a ticket is required to enter. Now called the Yawkey Concourse, it features eating establishments, shops, entertainment, and is the site of NESN, ESPN, and MLB pregame shows. Outside the right-field area on Van Ness Street is a striking display of Red Sox history, including banners, retired numbers, and statues.

The efforts of the current ownership have taken Fenway Park from the brink of extinction and transformed it into "America's Most Beloved Ballpark."

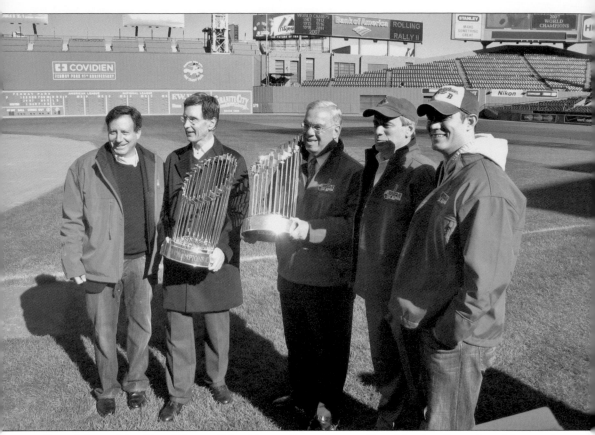

From left to right, Tom Werner, John Henry, Boston mayor Tom Menino, Larry Lucchino, and Red Sox general manager Theo Epstein pose with the World Series trophies from 2004 and 2007. When this ownership group, led by Henry, purchased the Red Sox in 2002, they did so amidst talk of a sports complex on Boston's waterfront, which would have meant the demise of Fenway Park. They chose to embark on a course that would not only restore Fenway Park, but bring it into the 21st century. Under their leadership, they not only restored, renovated, and modernized Fenway Park, but they employed the youngest general manager in baseball history and returned the team on the field to greatness the Red Sox had not seen since Fenway Park's inaugural decade. (Courtesy of Aaron Frutman.)

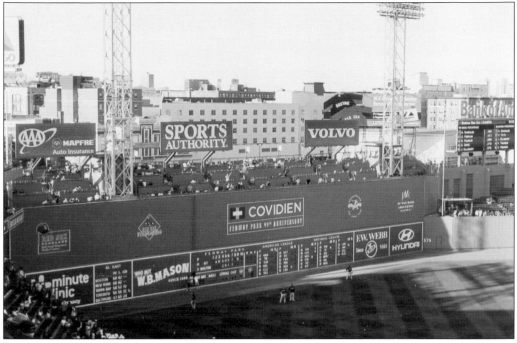

In 2002, the new ownership group made the decision that in order to keep the park financially viable for years to come, additional seats would be needed. That winter, one of the first major projects was undertaken to add seats to the top of the fabled left-field wall. The netting that had been there for decades to catch home run balls was removed, and 269 stools were installed. They would instantly be among the most coveted places to view a game in the park, providing many souvenir home run balls to "Monster" seat occupants. The new seats rendered the ladder on the left-field wall obsolete. Above is a view of the new section from high on the third-base side. Below is a view from the seats looking toward home plate. (Above, courtesy of Megan Tollerante; below, courtesy of Molly Keene.)

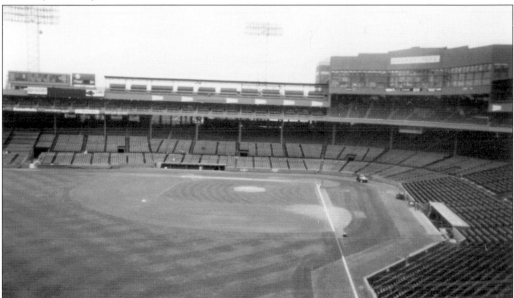

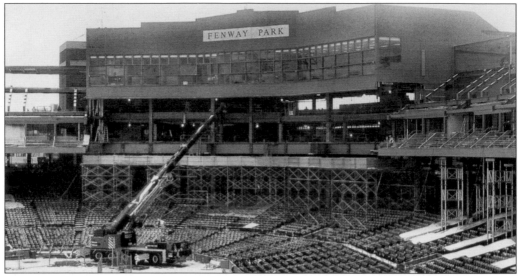

Originally built in 1989 and called the 600 Club, it became the 406 Club in 2002 following the death of Ted Williams. This was to honor the Red Sox great who was the last man to compile a .400 batting average, hitting .406 in 1941. Following the 2005 season, the 406 Club was renovated, creating two new levels of seating—the EMC Club and the State Street Pavilion. Along with one of the best views of the entire field, the EMC Club provides a fine dining room, three full-service bars, and a year-round function facility. (Above, courtesy of Steve Trapani; below, courtesy of Rachael Corragio.)

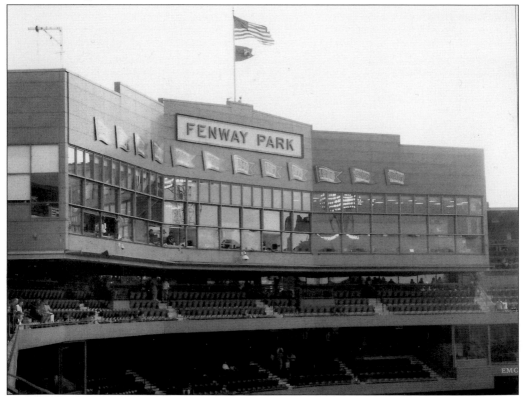

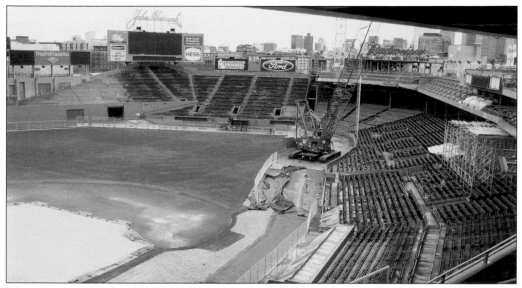

The renovation of the 406 Club also included improvements to 12 existing private suites in the State Street Pavilion. The addition of the new seating was accompanied with new restrooms and concession stands, and 1,000 seats were added to the capacity of Fenway Park, bringing it up to 35,108. The entry level to the First Base Concourse of the State Street Pavilion houses the plaques honoring the members of the Boston Red Sox Hall of Fame. The addition of this fourth level of Fenway Park has had its effect on the field as well. The new height has affected the wind currents, and Fenway Park is no longer the home run paradise it once was known to be. (Above, courtesy of Kristen Estabrook; below, courtesy of fenwaypark100.org.)

In this view of the concourse underneath the first-base grandstand, Fenway fans can see concrete and bricks that have been in place since the park's early years. However, the concession stands have expanded their menus far beyond the typical, traditional ballpark fare of long ago. Management continues to improve and update the culinary and souvenir offerings. (Courtesy of Zachary Keene.)

Fans enter the Ipswich Street bleacher entrance in deep right-center field for a sunny afternoon day game. This open-air area leads out to the expansive center-field concourse that includes a wide variety of vendors. The expanded area is one of the many new innovations from the new ownership and architect Janet Marie Smith. (Courtesy of Zachary Keene.)

A photograph from the south corner of Yawkey Way shows Fenway's main entrance as it appears today. One hundred years has brought countless changes to the original structure, yet despite it all, the brick facade that was completed in early 1912 is clearly recognizable as is the flourishing oak tree which, planted in 1912 and present in the photograph on page 15, has grown with Fenway. (Courtesy of gratefulevermore.wordpress.com.)

This view is from the west side of Brookline Avenue looking directly down Landsdowne Street on game day. The overhang of the "Monster" seats can be seen looming over the sidewalk on the right side of the street. To the far right, the Game On! sports bar now occupies the space that for decades housed a bowling alley on its lower level. (Courtesy of fenwaypark100.org.)

The Rolling Stones kicked off their worldwide Bigger Bang Tour to a sold out Fenway Park in August 2005, solidifying a tradition that began in 2003 with Bruce Springsteen and the E Street Band. The Springsteen concert was Fenway's first in 30 years. The success of Springsteen, the Stones, and those who followed has made the annual concerts one of the highlights of the Fenway summer. (Courtesy of Alexis Smith, www.L3xy.com.)

Sir Paul McCartney played before two sold out Fenway crowds in August 2009. The year 2012 will mark the 10th year of this tradition, which has seen the likes of Jimmy Buffett, Neil Diamond, and Sting, among other performers. Fenway saw its first concert in 1920 when John Philips Sousa played before a Fenway crowd; in 2012, the Fenway yearly concerts have become one of the summer's most anticipated events. (Courtesy of Stuart Merle.)

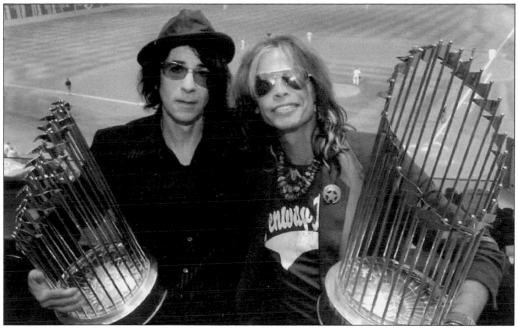

Boston-area rock legends Peter Wolf (left) of the J. Geils Band and Aerosmith's Steven Tyler hold the Red Sox World Championship trophies from 2004 and 2007. The pair visited Fenway Park on April 7, 2010, for a Red Sox-Yankees game just after tickets had gone on sale for their concerts four months later. (Courtesy of author's collection.)

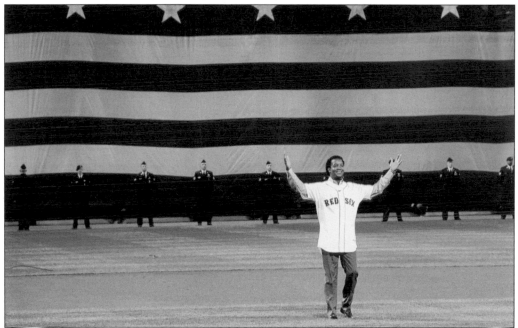

Pedro Martinez made a triumphant return to Fenway Park for opening day in 2010. He pitched for the Red Sox from 1998 through 2004 and was an astonishing 117-37. One of the most dominant pitchers to ever play the game, Pedro won the Cy Young Award in 1999 and 2000. His last win with the Red Sox came in Game 3 of the 2004 World Series. (Courtesy of Ian C. Corcoran.)

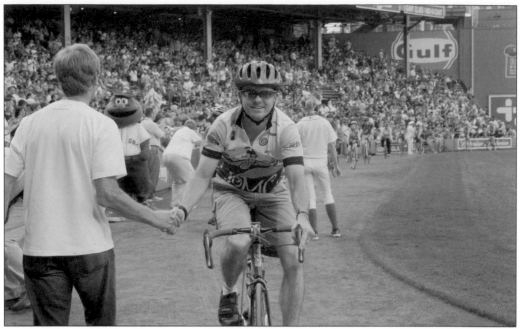

Billy Starr's Pan Mass Challenge has been raising money for cancer research since 1980. In 2003, the Boston Red Sox became their primary sponsor and in so doing opened up Fenway Park to a plethora of events that support their noble cause. The bicycle challenge now ends every year at Fenway Park. Here, a rider comes to the end of his ride. (Courtesy of author's collection.)

Soccer returned to Fenway Park in 2010 when over 32,000 fans showed up for a match between the Celtic Football Club of the Scottish Premier League and the Sporting Clube de Portugal of the Liga Sagres. Celtic forward Paul McGowan drove home a goal in sudden death, giving the Celtic club possession of the first ever Fenway Football Challenge Trophy. (Courtesy of Red Wylie.)

On April 8, 2008, members of the Boston Celtics, Boston Bruins, and the New England Patriots gathered at Fenway Park. Celebrating the Red Sox World Championship of 2007, each team toted championship trophies. Among the legends were Bobby Orr, Johnny Bucyk, "Pie" McKenzie, Ken Hodge, Bill Russell, John Havlicek, Danny Ainge, Teddy Bruschi, Larry Izzo, and Kevin Faulk. (Courtesy of Justin Wilcox.)

Massachusetts senator Ted Kennedy throws out the first pitch of the 2009 season. Kennedy served in the US Senate from 1962 until succumbing to brain cancer in August 2009, and he often visited Fenway Park. An iconic figure in American politics, Kennedy died with the third longest tenure of Senate service in US history. (Courtesy of Ima Manchi.)

The past decade has seen Fenway Park become a movie star. *Fever Pitch* (2005) and *The Town* (2010) were both premiered there and filmed extensively there as well. In fact, *Fever Pitch* was filmed throughout the 2004 season, and the ending had to be changed to accommodate the Red Sox World Series victory. Fenway also played a major role in the 1989 sensation *Field of Dreams*. (Courtesy of author's collection.)

On January 1, 2010, the Winter Classic featured the first ever hockey game played at Fenway Park where the Boston Bruins defeated the Philadelphia Flyers 2-1 in overtime. The closest Fenway Park had come to hockey before 2010 was when the Boston Tigers of the Canadian American Hockey League, a Bruins farm team, held a workout there 82 years earlier in 1928. (Courtesy of Henry Zbyszynski.)

The Yawkey Concourse has now become the favorite location for all pregame television broadcasts. Here, Dennis Eckersley and Jim Rice are doing the pregame show for NESN on the night Jim Rice's number was retired in July 2009. Rice and "Eck" were Red Sox teammates from 1978 through 1984, and they are now teammates in the National Baseball Hall of Fame in Cooperstown. (Courtesy of the lovely Lynda Jeanne.)

Jerry Remy played for the Red Sox from 1978 through 1984. He joined the NESN broadcast team in 1990. During his 21-year tenure as the Red Sox color commentator, he has worked side by side with a host of broadcasters from Ned Martin to his current partner Don Orsillo, becoming a Fenway Park legend. The "Remdawg" was the first president of Red Sox Nation. (Courtesy of Bostonnightclubs.com.)

In 2011, four-year-old Addison Rhodes made her first visit to Fenway Park, marking her family's fourth generation of Red Sox fans. Her great-grandfather passed away in 1998, never having seen his beloved Red Sox win a World Series. In 2004, her grandfather rejoiced as the Red Sox won their first World Series in 86 years. Her mom has seen two World Series wins, and she awaits another. (Courtesy of Beth Rhodes.)

The inaugural event for Fenway Park's centennial celebration was Frozen Fenway 2012. It was a hockey extravaganza featuring college and high school hockey games. This photograph features the final high school matchup, which took place on January 14, 2012—"Rivalry Day" between perennial powerhouses Catholic Memorial High School and Boston College High School. BC High prevailed 4-0. (Courtesy of Lynda Fitzgerald.)

The year 2012 marks the 100th birthday of Fenway Park. When the gates opened for the first time, William Howard Taft was president, women did not have the right to vote, there was no personal income tax, no such thing as a world war, and Babe Ruth had not yet played a major league baseball game. The induction ceremonies in Cooperstown in July 2012 will bring the number of that elite group to 297. Of those 297 members, 207 are players; of those, 87 percent of them have played at Fenway Park. There is no doubt that Fenway Park has played a most significant role in the history of America's pastime and thus in the history of America itself. The past 10 years have found Fenway Park undergoing more physical and structural changes than in the previous 90 years combined. The result has been two-fold, for 50 years has been added to its life and it has become the most visited landmark in the city of Boston. Let the next century begin! (Above, courtesy of Raymond Sinibaldi; below, courtesy of Lynda Fitzgerald.)

Discover Thousands of Local History Books
Featuring Millions of Vintage Images

Arcadia Publishing, the leading local history publisher in the United States, is committed to making history accessible and meaningful through publishing books that celebrate and preserve the heritage of America's people and places.

Find more books like this at
www.arcadiapublishing.com

Search for your hometown history, your old stomping grounds, and even your favorite sports team.

Consistent with our mission to preserve history on a local level, this book was printed in South Carolina on American-made paper and manufactured entirely in the United States. Products carrying the accredited Forest Stewardship Council (FSC) label are printed on 100 percent FSC-certified paper.

MADE IN THE
USA